D0601820

Scanwiches

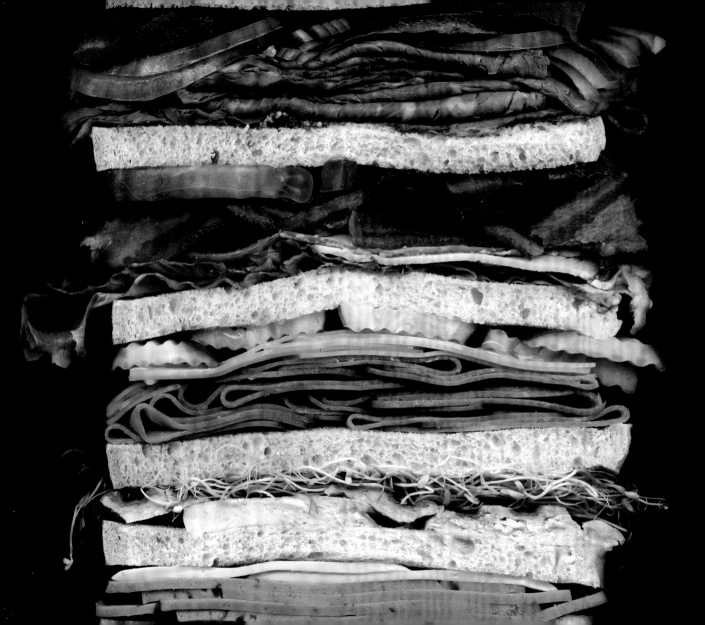

Scanwiches

by Jon Chonko

powerHouse Books
Brooklyn, NY

Scanwiches

Photographs & Text © 2011 Jon Chonko

Published in the United States by powerHouse Books,
a division of powerHouse Cultural Entertainment, Inc.
37 Main Street, Brooklyn, NY 11201-1021
telephone: 212.604.9074, fax: 212.366.5247
email: scanwiches@powerhousebooks.com
website: www.powerhousebooks.com

First edition, 2011

Library of Congress Control Number: 2011933145

Hardcover ISBN 978-1-57687-589-6

Printed and bound through Asia Pacific Offset
Book design by Jon Chonko

www.scanwiches.com

A complete catalog of powerHouse Books and Limited Editions is available upon request; please call, write, or visit our website.

10 9 8 7 6 5 4 3 2 1

Printed and bound in China

Thank you...

...to my family, Mom and Dad especially,
for teaching me, among many other
things, how to make a sandwich.

...to all my friends and coworkers for thinking
this was cool enough to put up with me
scanning their lunch and asking their help.

...to all my teachers who encouraged me not
to accept restrictions on creativity even when
it meant misusing school equipment.

...to everyone at powerHouse Books for
getting excited about a little lunch blog.

...and to my girlfriend, Jacqui, for letting
me borrow her scanner even though she
knew what I was going to do to it.

Too few people understand a really good sandwich.

– James Beard

Scanwiches?

The first question people often ask is "why?" Why scan sandwiches? The answer to that is easy: There's something about a sandwich to which everyone can relate. They're one of the first meals you learn to prepare for yourself and one of the easiest comfort foods to put together in a pinch. We grow up with sandwiches, we grow old with them, they are the meals of our everyday life. They have cultural importance as well. Stories of regional and national identities are contained between the bread, of the Bánh Mì, the Po' Boy, the Hamburger, and many others.

More than most foods, the story of the humble sandwich reflects the world today, how we got here, and who we are. It's ironic then that it remains such a humble food, a working-class meal that feels so familiar and comfortably mundane.

Which is why scanning is so appropriate. It may be a little unorthodox, but a flatbed scanner has a way of taking a familiar object (like a sandwich) out of its expected context, isolating and abstracting it into a thing vividly wonderful and alien from the paper-wrapped meal people eat every day. It becomes special. It becomes important. It gives the modest sandwich a long overdue celebration. That's what *Scanwiches* is all about. Why scan sandwiches? Because they deserve it.

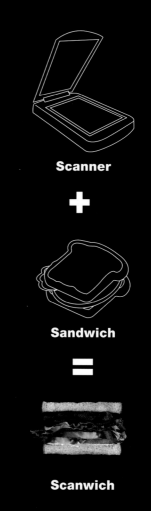

Scanner

+

Sandwich

=

Scanwich

Tip | By the Numbers

Ingredients in each sandwich are numbered and labeled beneath the sandwich name. These come in handy when you need to tell the difference between Swiss and Provolone.

2

1

Tip | Use Your Hands

Featured sandwiches are printed at 1:1 scale. By holding your hands over the book you can almost imagine it's real. If imagining doesn't satisfy you, make or find a real one.

How to Use This Book

Numbered ingredients usually sit here. Not every ingredient will be labeled, but key toppings crucial to a sandwich's identity are always included.

For Your Education and Delight

First, a bit of a disclaimer: Readers expecting to find a methodical and instructive cookbook, or a rich, thorough culinary history of sandwiches may be a little disappointed.

This book was made for people like myself, unashamed sandwich lovers who thrill at seeing old favorites and exotic creations in their best light. From cover-to-cover *Scanwiches* is designed to be a celebration, a visual shorthand of what is most beautiful, unique, and enticing about sandwiches of all shapes and sizes.

It doesn't have every sandwich in the world, and some people may find their favorite missing. To those people I apologize. But hopefully you will discover a childhood snack you loved or see something new that inspires you to put the book down and make it yourself, or even better, explore a new neighborhood or restaurant where that sandwich is offered. I hope at the very least it makes you hungry.

Tip | **Trivia**

Interesting facts clue you in about origins, ingredients, and preparation tips.

Tip | **Variations**

Variations on sandwiches help show the full-breadth of sandwich possibility.

Table of Contents

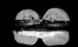

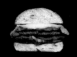

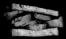

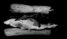

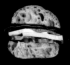
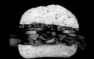

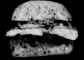

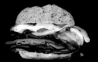
Chivito
Page 44

Chopped Liver
Page 46

Choripán
Page 48

Club
Page 50

Croque Monsieur
Page 52

Cuban
Page 54

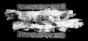

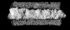
Denver
Page 58

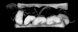
Egg Salad
Page 60

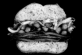
Elvis
Page 62

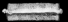
Fluffernutter
Page 64

Dagwood
Page 56

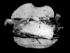
French Dip
Page 66

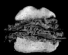
Fried Fish
Page 68

Gatsby
Page 70

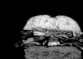
Grilled Cheese
Page 72

Hamburger
Page 74

Hot Dog
Page 76

Ice Cream
Page 78

Lobster Roll
Page 80

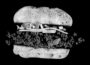

Loosemeat
Page 82

Marmite
Page 84

Melt
Page 86

Mitraillette
Page 88

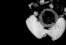

Mother-in-Law
Page 90

Muffaletta
Page 92

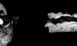

Pan Bagnat
Page 94

Panini
Page 96

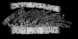

Pastrami On Rye
Page 98

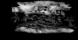

Patacón
Page 100

PB&J
Page 102

Pepper & Egg
Page 104

Ploughman's Lunch
Page 106

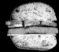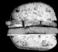

Po' Boy
Page 108

Porilainen
Page 110

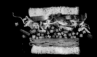

Primanti Brothers
Page 112

Reuben
Page 114

Rou Jia Mo
Page 116

Sandwich de Miga
Page 118

Sandwich Loaf
Page 120

Serranito
Page 122

Sloppy Joe
Page 124

St. Paul
Page 126

Stalwart Goatherd
Page 128

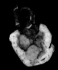

Street Fair Sausage
Page 130

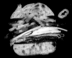

Submarine
Page 132

Tea Sandwich
Page 134

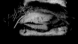

Thanksgiving
Page 136

Torta
Page 138

Tramezzini
Page 140

Tuna Salad
Page 142

Vada Pav
Page 144

Wurstbrot
Page 146

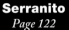

Yakisoba
Page 148

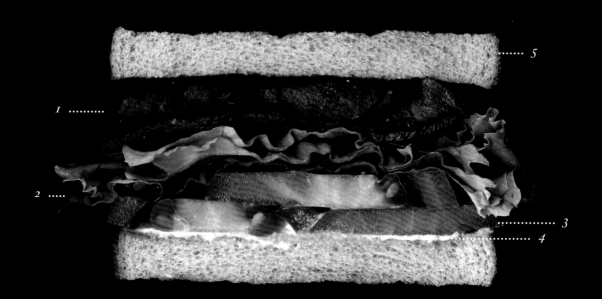

5

1

2

3

4

14

B.L.T.

1 Crispy Bacon, 2 Green Lettuce, 3 Tomato, 4 Mayo, 5 Toast

Their Powers Combined...

Bacon, lettuce, and tomato. Sure they have their fans, but alone, in other sandwiches, they're the underdogs, the optional toppings, sitting back while other ingredients get the limelight.

If sandwiches were a high school, lettuce would be then nerdy kid reminding you to eat healthy, poor tomato would be the chubby, red-faced outcast that the younger kids shunned, and bacon, though loved, would be a more popular meat's wingman, coming as an extra for another 50 cents, never getting its chance to run the show.

But under the right circumstances, they emerge from obscurity and combine, forming a sandwich that's simultaneously unique, familiar, and undeniably sublime. A little mayo helps, too.

The B.L.T. combo is so powerful it's become one of the most popular in the United States and the U.K. Not too shabby for a trio of optional toppings.

Bacon

Lettuce *Tomato*

Name | **B.L.T.**

The eponymous ingredients, bacon, lettuce, and tomato. The B.L.T.'s name likely comes from diners in the 1930s where the use of abbreviations were common.

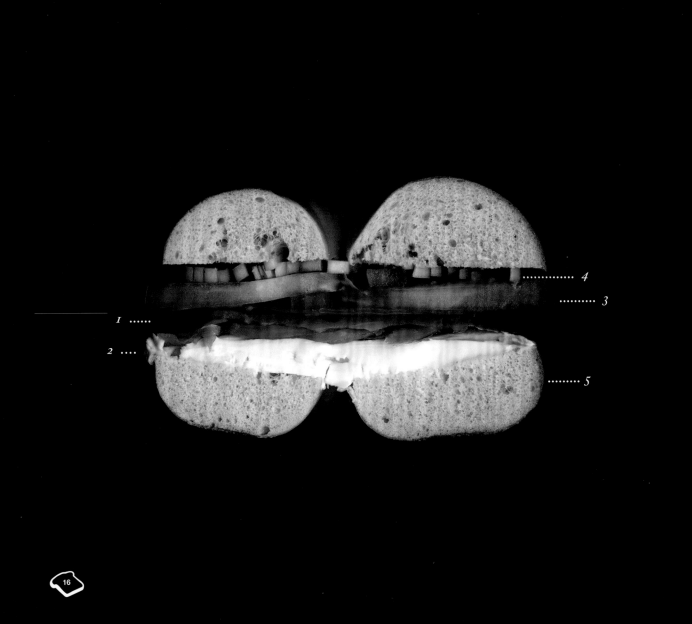

Bagel & Lox

1 Cured Wild Atlantic Salmon, 2 Cream Cheese,
3 Tomato, 4 Onions, 5 New York Style Bagel

Quality Ingredients

Since it was first brought to New York by Jewish immigrants over a hundred years ago, the bagel has become a crucial part of the city's deli cuisine; an icon of New York City eating alongside the pizza slice and Hot Dog. If the bagel is a New York icon, then cream cheese and lox constitute the iconic bagel sandwich.

A Bagel & Lox is all about quality. Skimping on the key ingredients can wreck the sandwich. The fish has to be just right—sweet, salty, and sliced thin by a deli worker who knows what he or she is doing. The bagel, also, is make-or-break. It has to be fresh and a little chewy, too hard and you're squeezing cream cheese and lox onto your hands with every bite. However, when done right, very little can compete with a well made Bagel & Lox sandwich. The sweet, salty, savory mix is one of life's greatest little pleasures.

Another popular bagel style exists in North America. The Montreal style is a smaller, sweeter, crunchier bagel with its own set of quality standards and makes a different, but no less tasty, sandwich.

Ingredient | **Bagel**

The first mention of bagels appears around 1610 in Poland as a "chewy, hard glazed roll of leavened bread...given as a gift to a woman in childbirth."

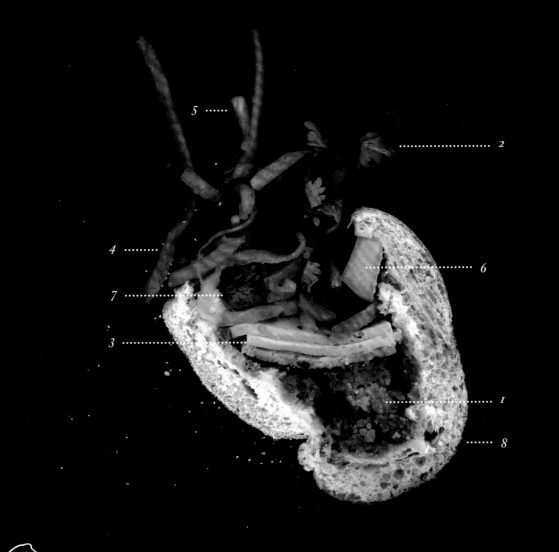

Bánh Mì

..

1 Grilled Pork and Cha, 2 Cilantro, 3 Paté, 4 Carrots, 5 Daikon,
6 Cucumber, 7 Chilies, 8 Baguette

..

A Revolutionary Sandwich

The story of the Bánh Mì is the story of modern Vietnam in a sandwich. It begins over 100 years ago during the peak of European imperialism in what was then called French Indochina.

The French imposed many things on the region during their time there. One of them was their bread, and it wasn't long before native Vietnamese cuisine rebelled.

Like a street-food Dien Ben Phu, Vietnamese ingredients took control of the baguette, and quickly replaced the old fillings with pork, daikon, and other local fare. Patés were allowed to stay—after all they are pretty tasty. Thus, the Bánh Mì was born.

By the time France pulled out (and the Americans came in) Vietnam had full custody of the Bánh Mì. It took some time to export but today it can be found worldwide.

Bánh Mì are fantastic meals. The combination of savory, spicy, fresh, and crunchy make them one of my favorite sandwiches.

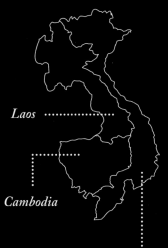

Laos

Cambodia

Origin | **Vietnam**

Bánh Mì is actually the Vietnamese word for *bread* and describes a family of sandwiches with very few hard and fast rules. Once the baguette was co-opted anything could go in. Bánh Mì today incorporate, chicken, beef, veggie, and vegan options without losing their signature style.

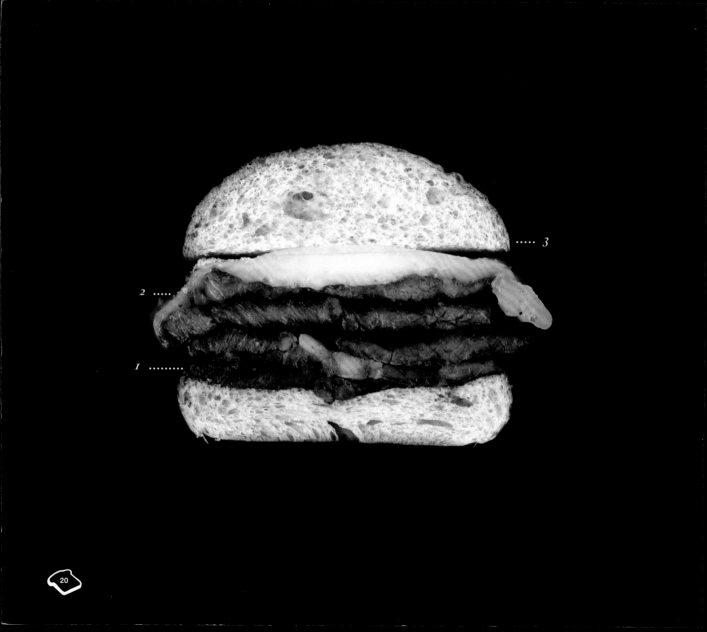

3

2

1

20

Barros Luco

1 Hot Grilled Steak, 2 Cheese, 3 Roll

One for the History Books

As the Earl can testify, a sandwich can have a peculiar way of granting people immortality. Although, sometimes it's not always the memorial they'd expect.

Ramón Barros Luco, among other things, was president of Chile from 1910 – 1915. He's remembered for doing very little except ordering the same delicious steak and cheese sandwich again and again from the restaurant of the National Congress of Chile. The sandwich, seen to the left, has carried his name ever since.

To make the story more interesting, Luco's cousin, Ernesto Barros Jarpa, an even less memorable politico, would ask the same restaurant for the same sandwich, substituting the steak for ham, and endowing his own name, *Barros Jarpa,* upon the tasty variation.

Not particularly noteworthy as public figures, Luco and Jarpa would have surely faded into the history books if not for their persistent preferences. Modern politicians fearing anonymity might look into leaving a legacy in the form of a mouth-watering sandwich.

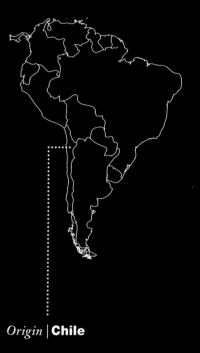

Origin | **Chile**

21

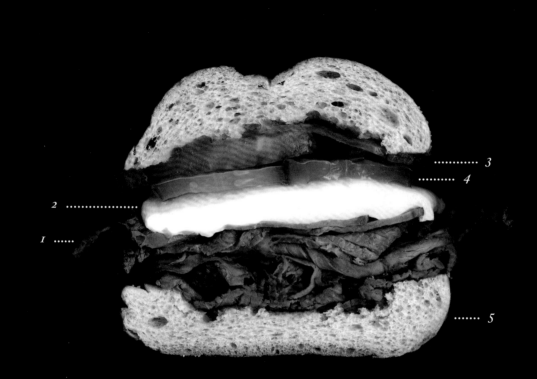

............ 3
........... 4

2

1

........ 5

Bauru

1 Thinly Sliced Roast Beef, 2 Melted Mozzarella, 3 Tomato, 4 Pickle, 5 French Bread with Some of the Crumb Torn Out

The Ponto Chic Kid

São Paulo 1934, the Ponto Chic Restaurant. Enter Casimiro Pinto Neto, a young law student and future radio personality. He recites to the waiter a sandwich recipe, thinking over each element as the sandwich nears completion. "Add roast beef," he says. "Now add a tomato," he whispers. Thus the Bauru was born.

That's a bit dramatic, but the actual history isn't much different, and (unusually for sandwiches) very well documented. Casimiro Pinto Neto did walk into the Ponto Chic (a joint that still exists today and maintains this origin story) and request the very same sandwich you see.

Inspired by a Department of Education and Health booklet written on proper childhood nutrition, Neto sought to create a snack that fulfilled the requirements for proteins and vitamins. Today the sandwich is a national icon and given its cheesy, beefy goodness, I'm sure the kids love it.

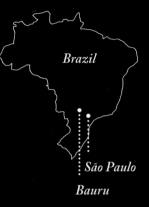

Brazil

São Paulo

Bauru

Origin | **São Paulo, Brazil**

The sandwich was first called a *Casey* after Casimiro Pinto Neto. However Neto was known affectionately by many in São Paulo as *Bauru,* the name of his nearby hometown. *Casey* didn't last long. "Bauru's sandwich" was overwhelmingly requested and ultimately became the sandwich's name.

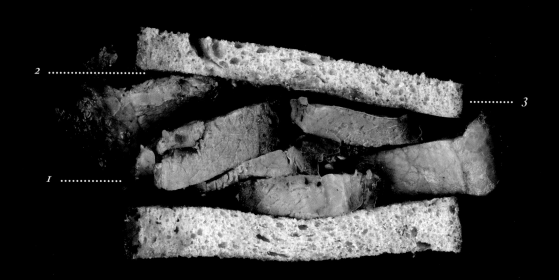

2 ..

3

1

BBQ Sandwich

1 Sliced, Slow-Smoked Brisket, 2 Sauce, 3 White Bread

Where There's Bread, There's a Sandwich

The way I see it, there are two types of BBQ Sandwiches. The first is ordered and made as a sandwich. These are the BBQ Sandwiches of food carts, drive-thrus, and county fairs.

The second happens more spontaneously at bona fide BBQ joints. The types of establishments, like the meat markets of my Central-Texas youth, that don't bother with anything else but serious brisket, ribs, or hog. The places that serve meat on a tray with a short stack of the whitest bread made by man. Inevitably, the fat and moisture from the meat overwhelm the diner. That's when the bread makes its entrance and a sandwich is born.

Whichever way a BBQ Sandwich comes in to being, it's invariably a rich, meaty experience for the person eating it.

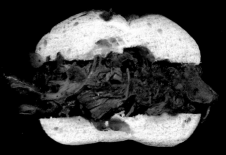

Variation | Pulled Pork

Sandwiches don't take sides in the great BBQ debates. Whether it's Texas brisket, or Memphis pulled pork, it all works between slices or on a roll.

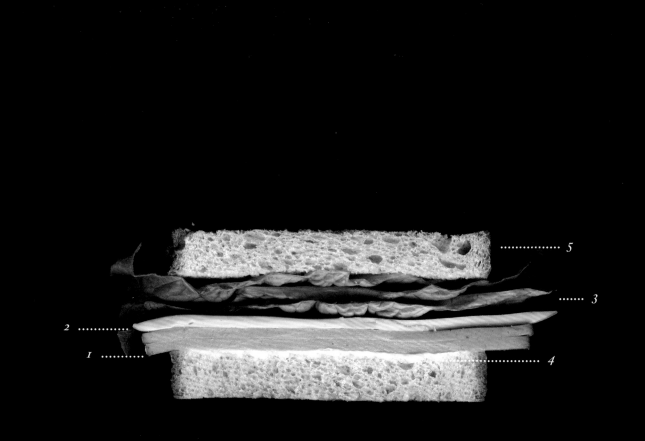

5

3

2

1

4

Bologna

1 Sliced Bologna, 2 American Cheese, 3 Lettuce, 4 Mayo, 5 White Bread

"Oh Baloney"

In a three-way tie with hot dogs and Spam, bologna may be the most maligned meat. From age-old worries over its ingredients, to more recent concerns over sodium levels, bologna gets an undeserved rap. Cheap and economical, it fills you up even if you don't know exactly what's in it and its oddly familiar taste is a comfort when you need it most. It's the ideal sandwich for those on hard times.

Maybe it's fitting then, that a Bologna sandwich was Bonnie and Clyde's preferred breakfast, washed down with a bottle of buttermilk each morning before they began their 9-to-5 stick-up business.

Like the outlaw lovers, bologna maintains a place in America's slowly clogging heart. Despite its short-comings and crimes against our better health, it still sells by the tons every year.

Key Ingredient | **Bologna**

Frying is a common way to perk up the lunch meat and Fried Bologna sandwiches are a popular variation.

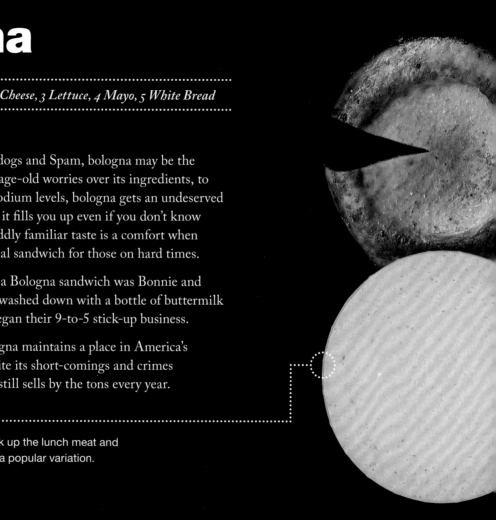

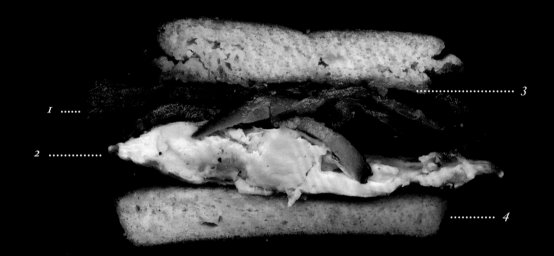

Breakfast Roll

1 Bacon, 2 Fried Egg, 3 Cheddar Cheese, 4 English Muffin

No Meal Left Behind

Nothing is sandwich-proof, and breakfast sandwiches are a perfect example of how a plate of food can easily go handheld.

The Breakfast Roll is often a straight translation of a traditional breakfast incorporating eggs, sausage, bacon, cheese, and whatever else will hit the spot. In the U.K. and Ireland the staples of a full fry up, including tomato, beans, mushrooms, and black and white pudding may find their way between bread.

Popular whenever a morning meal is needed but time or convenience is a priority, this sandwich's fans include the hungover and the morning commuters of the world.

Main Ingredient | **A Full Breakfast**

Breakfast foods don't just make up the inside of the sandwich, the bread used to hold the asemblage together can also come from the most important meal of the day. Anything from a croissant, to bagels, or pancakes might be used in lieu of the usual sliced bread found on other sandwiches.

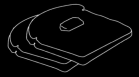

Toast

Bacon

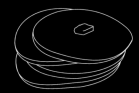

Pancakes

Eggs

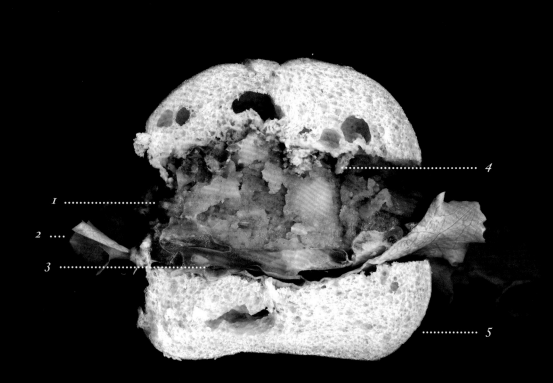

Bun Kabab

1 Potato Lentil Patty, 2 Lettuce, 3 Tomato,
4 Mint Yogurt Chutney, 5 Hamburger Bun

Pakistan's Sandwich

The Bun Kabab is part of a family of South Asian patty sandwiches that include the Dabeli and Vada Pav (p. 144).

A common street food in its native Pakistan, the Bun Kabab is a filling and amenable snack. The contents of the patty (the kabab) are flexible enough to accommodate diverse diets of Pakistan easily complying with vegetarian or halal preferences, a very important feature for any successful street food in the region.

Like its South Asian cousins, the Bun Kabab has started to emigrate from its native land and in recent years the sandwich has been spotted in a few U.S. and European cities. Keen sandwich aficionados looking for something different might want to check out the spicy patty between bread.

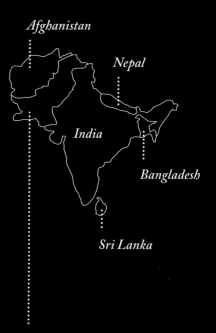

Afghanistan

Nepal

India

Bangladesh

Sri Lanka

Origin | **Pakistan**

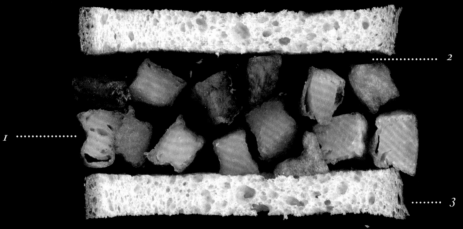

Butty

1 Chips (French Fries), 2 Ketchup, 3 Buttered White Bread

In the Spirit of the Earl

Butty is another term for a sandwich in the U.K. While it can technically be used to describe any sandwich, it tends to find itself attached to the single ingredient creations seen here.

At first, the idea of a sandwich full of fries (chips), potato chips (crisps), or bacon may seem a little confusing. However, what's happening is no different from what John Montagu, 4th Earl of Sandwich did centuries ago. Eaten in the usual manner, fries and chips leave your fingers greasy and dirty. Putting them between bread solves that problem.

Even if Butties aren't your cup of tea, it's inspiring to know that in the land of the sandwich's namesake, innovation continues.

Variation | **Bacon Butty**
Also called a Bacon *Sarnie.*

Variation | **Crisp Butty**

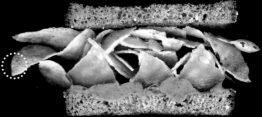

Potato chip sandwiches are more than just a Butty phenomenon. In fact, to many people worldwide, they're a necessary addition to any sandwich, the way bacon or cheese are for others. These people confuse and excite me.

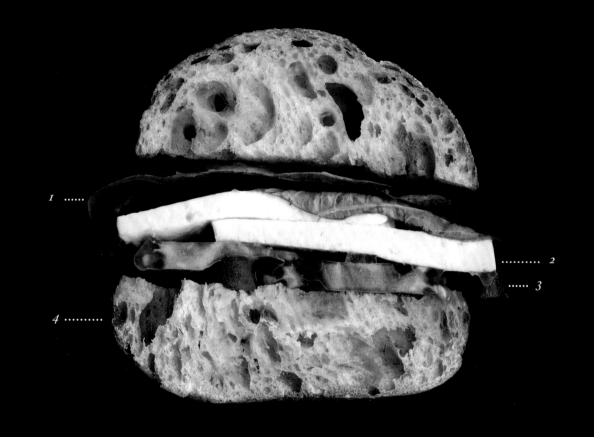

There are folks who don't like sandwiches. You, the reader, are not likely one of them, but trust me they do exist. They don't necessarily hate sandwiches, they just don't eat them. They are salad people.

If you're going to order a salad, the Italian Insalata Caprese is a great choice. Its simple combination of basil, mozzarella, and tomato can't be beat for a fresh summer snack. That is of course, unless you're a sandwich person.

A sandwich person doesn't hate salads, they'd just rather not deal with plates and forks when there's the option to put it all between bread. Thankfully for sandwich people, there's the Caprese sandwich offering the same refreshing combination in a portable bread embrace.

In some ways, Caprese is sort of a test; are you a sandwich person or a salad person? You may think you're both, but when it comes down to it would you rather eat it on a plate or in a crusty loaf?

Origin | **Capri Island**

Caprese draws its name from its supposed origin, the Italian island of Capri. The island has also lent its name to a style of calf-length pants that are also popular during summer months.

Main Ingredient | **il Tricolore**

No matter how it's eaten, the Caprese is one of the world's more patriotic foods. Its primary ingredients create an edible Italian flag.

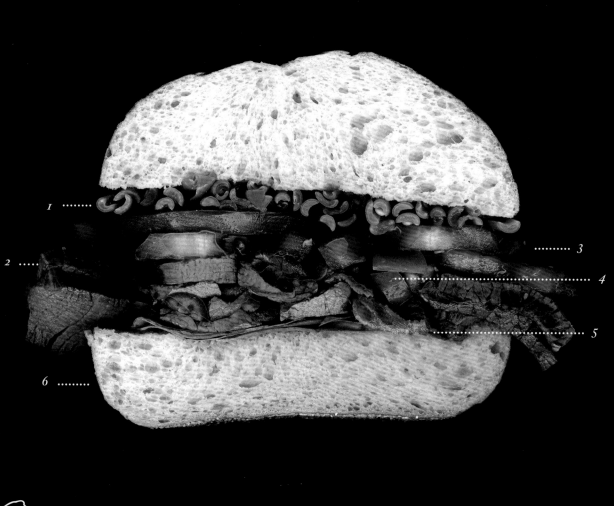

Chacarero

Cooked Green Beans, 2 Sliced Steak, 3 Tomato,
Jalapeño, 5 Lettuce, 6 Round Roll

Eat Your Vegetables

Most sandwiches emphasize fresh, crisp lettuce, ripe-red tomatoes, and crunchy onions. In Chile they make a sandwich with cooked green beans as the feature veggie and it works beautifully.

Whether it contains pork, steak, or any other meat, the Chacarero always includes a solid layer of green beans, cooked completely through. In a steak sandwich, especially, its a surprisingly good companion to the meat. But it makes sense that they would pair up so well. If a steak dinner with string beans on the side is delicious, why wouldn't the same ingredients make a mouth-watering sandwich?

It's good enough to make you consider what else our culinary prejudices have prevented us from creating? Maybe the Chacarero is a beautiful fluke, or maybe there's a brussels sprouts or broccoli sandwich waiting for the right entree and bread to come along to change the world.

Key Ingredient | **Green Beans**

The key ingredient, also makes a sweet, crunchy snack eaten raw.

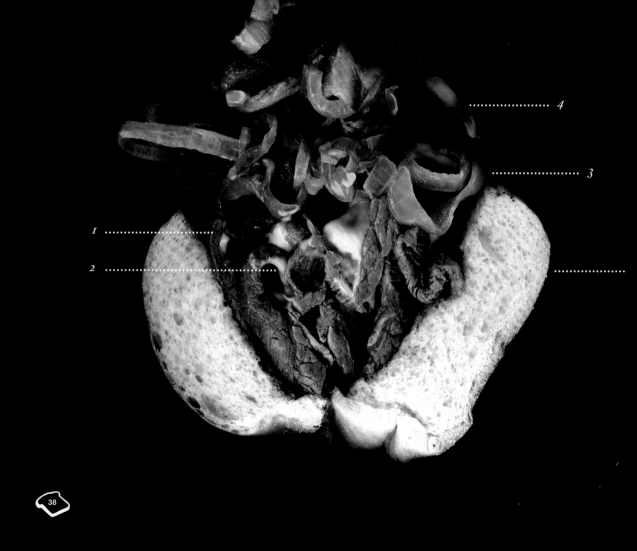

Cheesesteak

1 Grilled, Thinly Sliced Steak, 2 Melted Cheez Whiz,
3 Grilled Onions, 4 Mushrooms, 5 Hoagie

The Sandwich of Brotherly Love

Few sandwiches are as associated with a place as strongly as the Cheesesteak is with Philadelphia. Even fewer sandwiches arouse as strong opinions as this greasy hoagie.

Its origin, as with most sandwiches', is anecdotal, with the known facts pointing to Philly in the early twentieth century. Today there's little debate that the city owns the Cheesesteak. It holds it so close to its bosom, in fact, that it may have become a little overprotective. Cheesesteak zealots will question any sandwich that doesn't use the right cheese (Provolone, American, or Cheez Whiz), the right hoagie (Amoroso or Vilotti Pisanelli), and the most zealous dismiss any sandwich not bought within city limits.

The Cheesesteak shown was made at home in Brooklyn. It may be heresy to some, but like the rest of the country, where the hugely popular sandwich can be found in most delis and fast food joints, it's just too tasty to worry if it's a counterfeit or not.

Ingredient | Cheez Whiz

Michael Dukakis wore a helmet, Howard Dean screamed, and during his '04 campaign John Kerry requested Swiss on his Cheesesteak at an appearance in Philadelphia. Had he known better, and asked for Cheez Whiz, he may have been our 44th president.

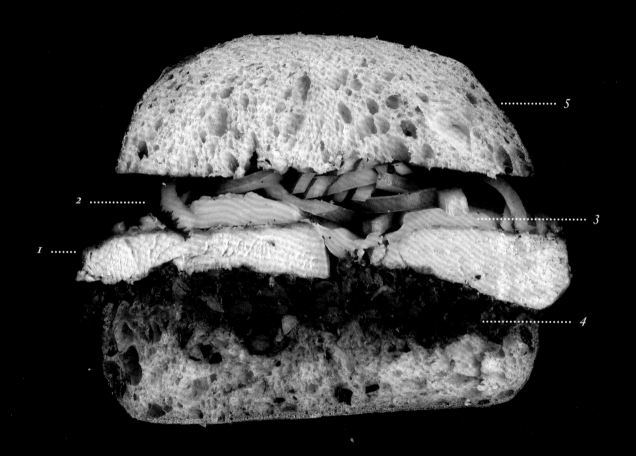

5

2

3

1

4

40

Chicken

1 Grilled Chicken Breast, 2 Onions, 3 Monterey Jack,
4 Refried Black Beans, 5 Round Loaf

Tastes Like Chicken

Chicken has a reputation for being a little dull. The ubiquitous breast, especially, seems to need a lot of help to taste like anything. For chicken, though, being boring is actually an asset.

Chicken as a whole is not dull, but it's the dark meat that's the tasty part, monopolizing most of the flavor. Maybe that's why the breast has become a star. Its mild flavor is like the tofu of meats (if that description doesn't cancel itself out), it's a protein that works however you dress it.

On a plate or sandwich, chicken will do anything to please. You can fry it, spice it, grill it with whatever you want, you can go places with chicken that beef or pork won't allow. It's happy to let the other flavors take center stage. The result is usually very tasty even if the chicken isn't the one standing out.

That attitude (and a low-fat content) have made it a headliner everywhere. Today, even burger franchises like McDonald's are in the Chicken sandwich business. When it comes to chicken, it pays to be unremarkable.

Ingredient | **Chicken**

Variation | **Fried Chicken**

41

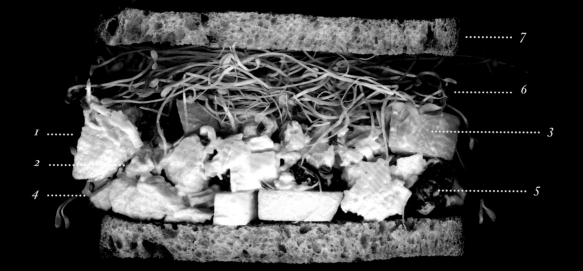

1

2

4

7

6

3

5

Chicken Salad

1 Cubed Chicken, 2 Mayo, 3 Apples, 4 Walnuts,
5 Raisins, 6 Sprouts, 7 Sourdough Bread

Chicken Any Way

If chicken breast is a mundane but adaptable meat, then chicken salad is the furthest expression of its flexibility. Chicken salad recipes are diverse and exciting. From spicy, savory curry salads to nutty and fruity Waldorfs, the only hard-and-fast rule is that it has to include chicken.

Putting it in a sandwich takes it up a notch. Not only are there endless variables in the salad itself but a whole new set of opportunities for toppings, bread, and condiments open up.

For me Chicken Salad sandwiches are about surprises. Going into a new deli and ordering a Chicken Salad sandwich is like punching a set of coordinates into a hyperdrive computer and pressing the launch button without looking at the destination. At its best, it's an exhilarating journey that takes you to the edge of the universe. At its worst, you find yourself in an asteroid field or at the edge of a black hole. If you're brave enough to do it, and survive, you feel a little more alive. You also know whether to get the chicken salad there again or not.

Variation | **Curry Chicken**

A deli-bought Chicken Salad sandwich. Some of the more prominent ingredients include shredded chicken, grapes, nuts, and spicy, creamy curry sauce.

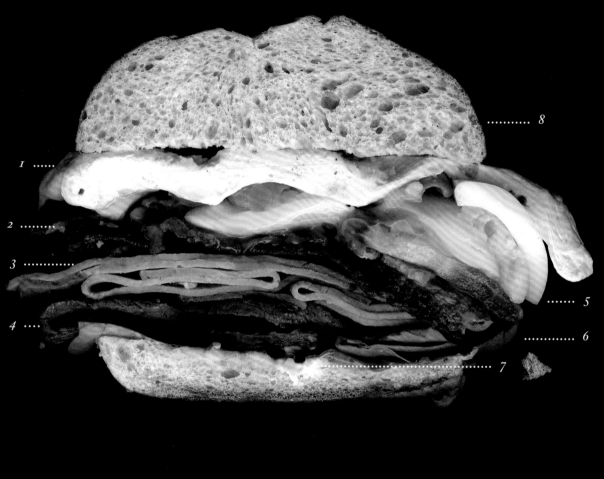

1

2

3

4

........... *8*

........ *5*

............. *6*

........................ *7*

Chivito

1 Melted Mozzarella, 2 Bacon, 3 Ham, 4 Sliced Steak,
5 Boiled Eggs, 6 Lettuce, 7 Mayo, 8 Round Roll

Uruguay's National Secret

Uruguay is a country full of surprises. It ranks as one of the greenest nations, the most livable, and was the first South American nation to legalize same-sex unions. In some ways Uruguay is the best little country you never hear about.

Add to that list of surprises, the Chivito. A true beast, the sandwich is piled high with steak, bacon, ham, eggs, and anything else that will fit. Rarely seen north of the equator, it remains illusive prey for most sandwich hunters. Like spotting Bigfoot or Nessie, it's a sandwich that haunts you after first spotted and food message boards are littered with stories of Chivito encounters from survivors hungry for more.

Maybe it's a good thing that the Chivito is so rare. After all, the United States' Hamburger was exported so aggressively it's almost lost meaning as a sandwich and even raised ire as it displaced local sandwich populations. Maybe keeping the Chivito in Uruguay preserves its purity and makes finding them outside their natural habitat all the more exciting.

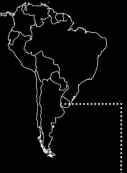

Origin | **Uruguay**

Where the wild chivito's roam in abundance.

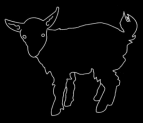

Name | **The Little Goat**

Chivito actually means *little goat*. Legend says, one evening a diner requested cooked goat, when the restaurant had none, they served the sandwich instead.

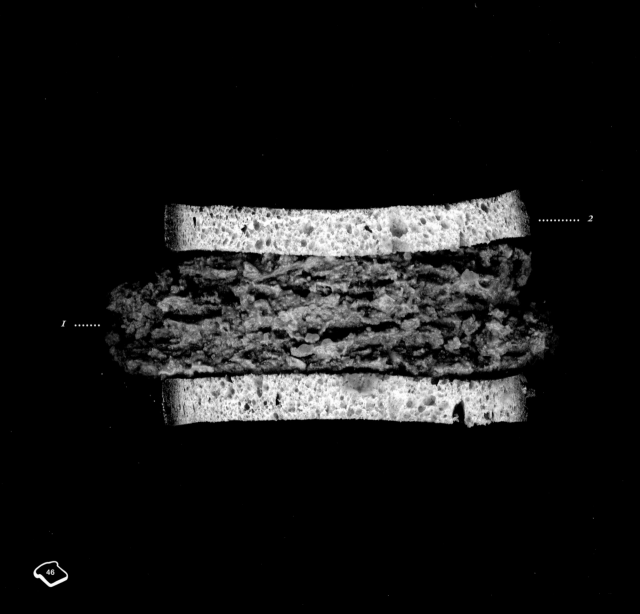

1

............ 2

46

Chopped Liver

What Am I?

Chopped Liver gets no respect. Of the classic Jewish deli sandwiches it's easily the most ignored. Like a late bloomer, though, sometimes all it takes is patience and understanding to see it come into its own.

Good chopped liver is a barrage of flavors. A blend of sauteed onion, liver, schmaltz, and spice gives it a unique quality and consistency that you either love or hate. By itself, it makes a nice spread on rye or crackers. As a sandwich it's creamy and rich and its paste-like consistency lets you pack it as thick as you want.

However, the real magic happens when it's brought together with one of its deli cousins. Combine it with corned beef or pastrami and it transforms the sandwich, its flavor and texture contrasting nicely with the rich meat and its consistency holding the two together on bread. Chopped Liver may stand in the shadows of its relatives but there's no doubt it's a valuable member of the family.

Beef

Calf *Chicken*

Ingredient | **Meat Liver**

Beef, calf, and chicken livers are most commonly used in chopped liver. Calf liver is the most tender and delicate of the three.

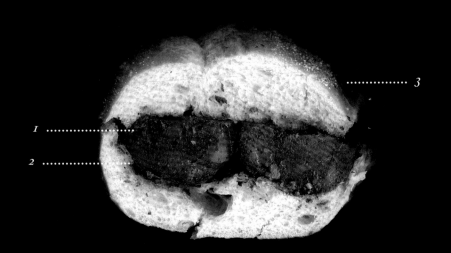

3

1

2

Choripán

1 Grilled Chorizo Sausage, 2 Chimmichuri Sauce, 3 Long Roll

We Are All Choripaneros

The Choripán is the Argentinian equivalent of a Hot Dog (p. 76). Like its relative, it's designed to be eaten on the go. Something quick, cheap, and achingly delicious.

The sandwich consists of a hot, grilled chorizo sausage and some spicy chimmichuri sauce on a crusty bun. It's a hugely popular street food that people in all walks of life and vocations enjoy. Cab drivers in Buenos Aires famously run out of their cab between fares to grab Choripáns. Football fans scarf them down before, during, and after matches. It's even a popular snack at political functions. Its constant presence at Peronist rallies has led to the nickname "Choripaneros" to describe hard-right politicos in Argentina.

The nickname is a little unfair to the sandwich. If everyone walking down the street with one in their hand shared the same political views, then Argentina would be the smoothest running democracy on the planet.

Ingredient | Chorizo

The Choripán's name is a clever portmanteau of *chorizo* and *pan* (Spanish for *bread*). You can ask for your sausage whole or split lengthwise, like a butterfly (*mariposa*).

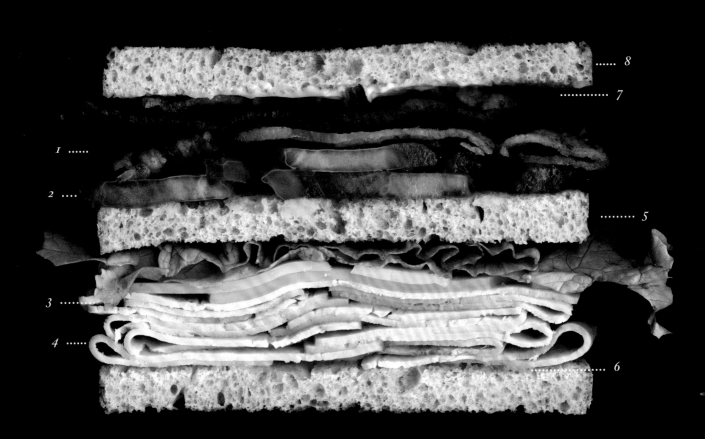

8

7

1

2

5

3

4

6

Club

1 Bacon, 2 Tomato, 3 Swiss, 4 Roast Chicken, 5 Lettuce,
6 Mustard, 7 Mayo, 8 Three Slices of White Toast

The Prestigious Club

The Club sandwich is an American classic. From its ritzy name to its novel, three-toast construction, few sandwiches are as iconic.

Its name rolls off the tongue, but how it was dubbed is a matter of debate. The most popular theory claims the Club was first made at the Sarasota Club, a New York Casino. Another asserts it came from the double-decker club cars of late-nineteenth century railroads. A third says it's the result of a late night snack, after a club patron returned home and raided the kitchen for a bite.

The three-toast construction, too, is the result of a century of experiments. In the 1890s one recipe describes the sandwich with only two slices of toast. In the 1920s another recipe went off the deep end, claiming up to five layers of bread and any ingredients the sandwich maker chose to use.

At the end of the day the origin and evolution doesn't really matter. A double-decker Club is a satisfying meal for anyone, whether on a train, at a casino, or coming home from a late night of partying.

Origin | **The United States**

The Club has the honor of being mentioned in the official record of the U.S. Congress. In 1930, during a heated debate regarding funds appropriated towards a House of Representatives restaurant, a Mr. Murphy of Ohio angrily protested the bill, waving a meager Club sandwich from the restaurant for all to see. Murphy was outraged that the place should be subsidized with federal dollars when it charged the heinous price of 70 cents for the subpar sandwich.

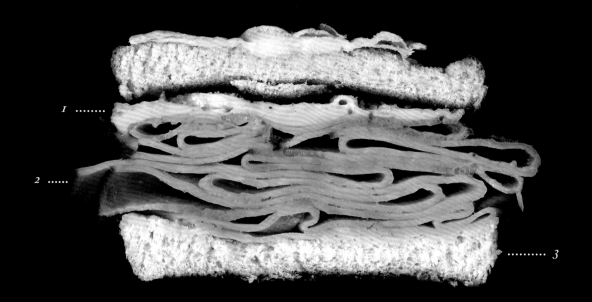

1

2

.......... 3

Croque Monsieur

1 Melted Emmental, 2 Ham, 3 Buttered Bread

The Name Game

A Croque Monsieur is France's classic, hot ham and cheese sandwich. A typical Croque is made with two slices of bread, ham, and a considerable amount of cheese inside and on top of the sandwich. The whole construction is then fried or grilled in clarified butter until thoroughly toasted and melted together.

For those who skipped French, *Croque Monsieur* translates very roughly to *Crunchy Mister.* The origin of the name is a bit of a mystery but the sandwich begins popping up in the records around Paris in the early twentieth century.

The name has given makers of Croque variations a clever convention for their own sandwiches, spawning a whole Croque family. Add egg and you have a Croque Madame. Drop some salsa on it and it's a Croque Señor. Swap the ham for smoked salmon and you've made a Croque Norwegian. Even McDonald's in France has played along, naming the ham and cheese sandwich they offer locally the Croque McDo.

Variation |**Croque Madame**

Variation | **Monte Christo**

The American Monte Christo does to the classic Croque Monsieur what Disney did to *The Hunchback of Notre Dame*. It's batter-fried and served with jelly and powdered sugar until it's so sweet you barely recognize it.

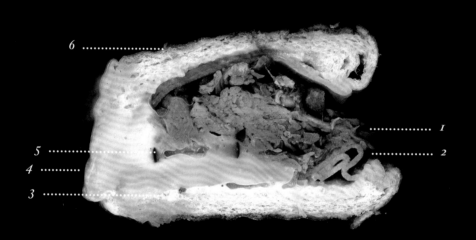

6

1

5

2

4

3

Cuban

1 Roast Pork, 2 Ham, 3 Mayo, 4 Swiss, 5 Pickle, 6 Cuban Bread

The Mixto

More than 100 years ago Cuban immigrants came to Florida seeking jobs in the state's then-thriving cigar and sugar industries. They brought with them a sandwich called the Mixto, a mouth-watering combination of Cuban bread, ham, pork, cheese, and pickles.

More than a century has passed since the Mixto was brought to American soil but remarkably all that time has had very little effect on the sandwich. The only striking difference between the worker's ham and cheese sandwich and the one made today is the name, Cuban, a nod to the sandwich's origin. In fact, today, back in Cuba, asking for a Mixto will get you a sandwich that looks and tastes almost exactly like the Cuban's of Miami and New York.

In a country where there is a Hot Dog variation for every region, and a sandwich like the Club has been through dizzying stages of experimentation, it's remarkable that the Cuban would emerge from the American melting pot intact. The fact that it has is a testament to how perfectly conceived the sandwich is. It's a meal that even the most cynical eater would have a hard time improving.

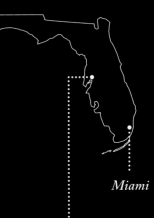

Miami

Origin | Ybor City

Although it's associated with Miami, the Cuban actually traces its roots to Ybor City, an early cigar manufacturing center now located within present-day Tampa city limits.

1
2
3 16
 17
4
5
 15
6
7
8
9
10 14
 13
11
56
 12

Dagwood

1 Grilled Red Peppers, 2 Onions, 3 Roast Beef, 4 Tomato, 5 Bacon, 6 Lettuce, 7 Pickles, 8 Sliced Cheddar, 9 Sliced Ham, 10 Grilled Chicken, 11 American Cheese, 12 Pimento Loaf, 13 Honey Mustard, 14 Sprouts, 15 Smoked Deli Turkey, 16 Course Seeded Mustard, 17 Sliced White Bread

The Concept Sandwich

The Dagwood is the nom-de-sandwich of *Blondie* character, Dagwood Bumstead, who would fill a loaf of sliced bread with refrigerator leftovers. Today the sandwich still largely remains a work of fiction, a myth of sandwich possibility. Anything resembling Dagwood's midnight snack in the real world would be impossible to eat, too tall to bite, and too much food to dream of finishing.

However, the Dagwood serves as a thought experiment, a look at what happens beyond the usual breaking point of a sandwich. The same way the auto industry creates radical cars as manifestations of pure design concepts, the sandwich gods have given us the Dagwood, a glimpse of a sandwich without rules or limits. Anything can go in; prejudice, tradition, and laws of physics go out the window. The Dagwood is a glimpse at the maximum potential of the sandwich form and may be inspiration for future, more practical, combinations.

Sandwich Tool | **Skewers**

A Dagwood may rarely exist in the real world but if you seek to create one a bamboo skewer is a must for holding it together.

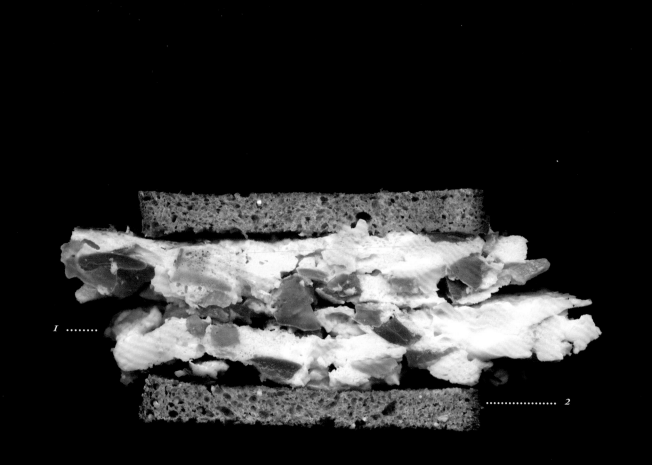

1

.................. *2*

58

Denver

1 Denver Omelet, 2 Multi-Grain Toast

An Omelet in Your Hands

You really can make a sandwich out of anything. The Denver sandwich proves this point by putting a Denver omelet between bread.

The origins of the Denver omelet itself, are a mystery. Some connect it to railroad cooks in the American west, many of which were Chinese immigrants, pointing to its similarity with egg foo young, a dish burdened with its own complicated origin. Others compare it to the frittata and quiche, both often filled with ingredients similar to the Denver's classic fare. However, both are made differently than the omelet and lack its definitive fold.

Neither story easily answers the question of the Denver omelet's history. But even if the origin of the meal isn't satisfying, the omelet always is. One of the heartier breakfast choices, a well made Denver omelet is guaranteed to fill even the hungriest lumberjack or long-haul trucker. It's only natural that such a neatly packaged and satisfying breakfast has found its way into a sandwich. Take what's great about a Denver omelet, put it between two slices of toast and you've got the Denver sandwich.

Ham

Onion

Cheese

Pepper

Eggs

Ingredient | **Denver Omelet**

The Denver omelet, (also called a *western omelet*) usually includes diced ham, green peppers, onions, and cheese.

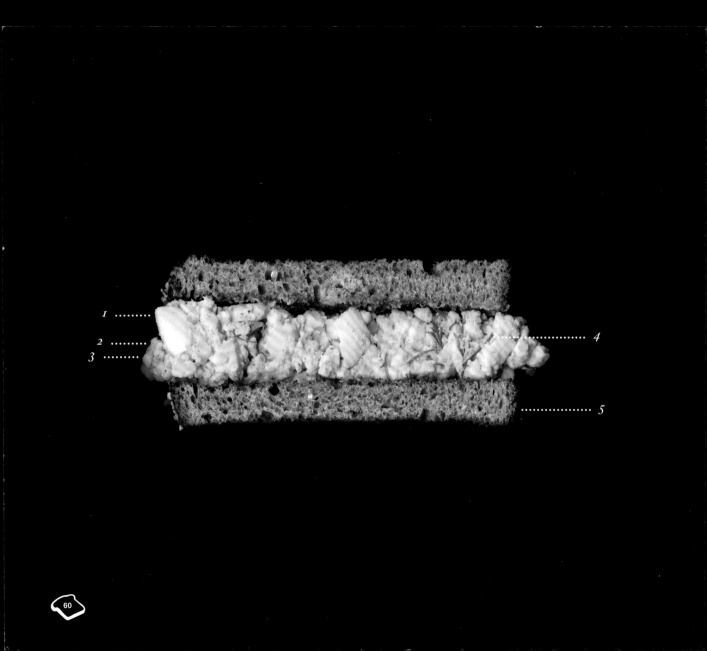

1

2

3

4

5

60

Egg Salad

1 Chopped Egg, 2 Mayo, 3 Mustard, 4 Dill, 5 Wheat Toast

The Egg Sandwich

Eggs were one of the things I hated as a child. Cold, solidified egg yolks were like poison to my 10-year-old palate. It took me a long time, and more than a little food therapy, to accept hard-boiled eggs as an adult. Even now, though I like to believe I am an adventurous, non-picky eater, I approach hard-boiled eggs with great caution.

An Egg Salad sandwich was the thing that changed my opinion of hard-boiled eggs. Like its other "salad" cousins (Tuna and Chicken) the make-or-break of Egg Salad is all in the spicing. The first time I tasted a well made Egg Salad I was floored. It was a sensation of simultaneous elation and confusion as my mouth rebelled against my mind's prejudices.

The sandwich had the perfect levels of paprika, dill, and the golden mustard/mayo ratio. But most importantly, it didn't lose its eggy taste. I found I actually *liked* its eggy taste and by the end of the sandwich I had almost forgotten my childhood aversion to hard-boiled eggs. Sometimes hating a food means you just haven't had it in a sandwich yet.

Official Season | **Spring**

The beloved Egg Salad has two official American holidays. The first, National Egg Salad Week, falls right after Easter Sunday, a time when many households are burdened with a glut of painted hard-boiled eggs. For those that don't get enough Egg Salad that week, the entire month of May is officially Egg Salad Month.

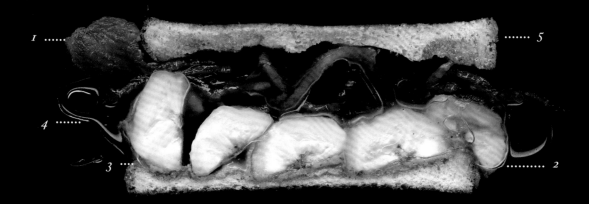

1 *5*

4

3 *2*

Elvis

1 Bacon, 2 Banana, 3 Peanut Butter, 4 Honey, 5 Toasted White Bread

A Meal Fit for the King

Elvis was known for many things. He was a musician, an actor, a soldier, a trendsetter, and a fashion faux pas. He was also a sandwich guy, with a taste for the rich and excessive.

Elvis' diet was as over-the-top as his latter-day rhinestone jumpsuits. Among his more famous requests was a sandwich known as the Fool's Gold Loaf: a jar of jelly, a jar of peanut butter, and a pound of bacon stuffed in a hollowed loaf of bread. Other sandwich requests were a little more reasonable. The most famous of those, a peanut butter, banana, and bacon sandwich, has adopted his name.

The Elvis truly is a sandwich fit for the king. The bacon, peanut butter, and banana is almost too decadent to believe and surprisingly addictive. Add a little honey to the mix and you're all shook up.

Variation | **PB&B**

There are many reports validating the peanut butter and banana sandwich as Elvis' favorite but not all of them include bacon. Most likely, like anyone, Elvis had his moods and those moods didn't always include the salty meat.

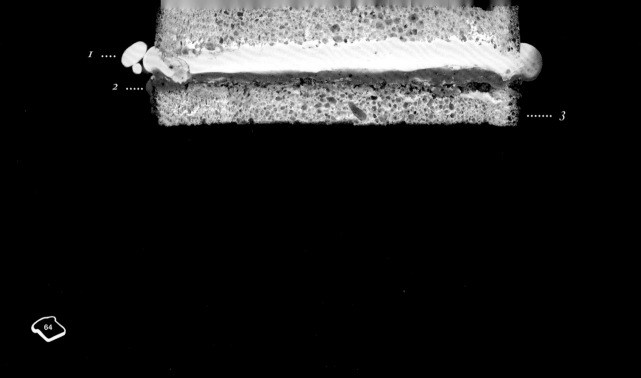

1

2

........ 3

64

Fluffernutter

1 Marshmallow Fluff,® 2 Peanut Butter, 3 White Bread

The New England Schoolyard Snack

A Fluffernutter is one of those regional sandwiches that's never truly exported from its land of origin. For anyone raised within the New England states of Maine, Massachusetts, Rhode Island, New Hampshire, Vermont, or Connecticut, the sandwich often prompts a strong rush of memories, fond childhood recollections of 3ʳᵈ grade lunches packed carefully by mothers who drop Rs off the end of words.

For anyone raised in the other 44 states, the sandwich draws a different range of reactions. Awe, curiosity, and even shock. Unfair condemnations from prudish sandwich Puritans, who are probably just afraid to sweeten up their lunch with a little dessert.

In many ways, the Fluffernutter shares a lot with its regional baseball team, the Boston Red Sox. Fiercely adored at home, its unenthusiastic treatment by others has only made Fluffernutter fans more dedicated. More than once, bills have been presented in Massachusetts state legislature to name the Fluffernutter the state sandwich.

CONTAINS CORN SYRUP, SUGAR, DRIED EGG WHITE, VANILLIN.

Marshmallow fluff®

NET W 7½ O 213g

Key Ingredient | **Fluff**

The sandwich's heart and soul. Marshmallow Fluff ® manufactured by Durkee-Mower Inc. of Lynn, Massachusetts since the 1920s.

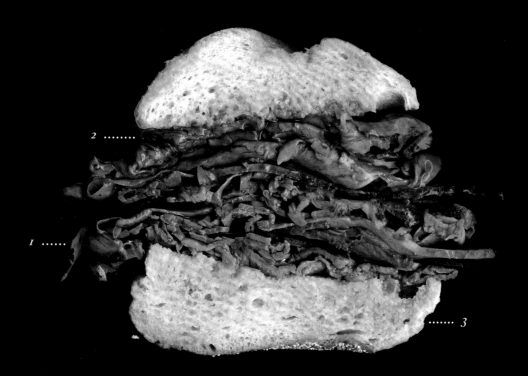

2

1

........ 3

66

French Dip

..

1 Thinly Sliced Roast Beef, 2 Au Jus, 3 French Bread

..

Dip Your Partner

Most sandwiches don't have a ritual in eating them. They're assembled and then you eat. There may be some secondary step that's up to the discretion of the eater, but for the most part, eating a sandwich is a one-step affair. The French Dip, on the other hand has become a delicious two-step.

There are two restaurants that claim to have created the sandwich, Cole's P.E. Buffet and Philippe The Original. To make it complicated, both are in L.A. and both were founded the same year. However, If you order the sandwich at either location you'll be greeted with one "pre-dipped" and soaking in au jus. This may be the original but, thankfully, its no longer the norm. Outside the two institutions most French Dips are served with the au jus on the side.

What the originals miss is the fun that having au jus on the side brings. The meal becomes and activity, one of the few chances you have as an adult to play with your food in public. Besides the little bit of interaction it adds, you're able to enjoy that magic second before the bread turns to mush, a problem pre-soaked sandwiches can develop.

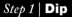
Step 1 | **Dip**

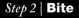
Step 2 | **Bite**

Step 3 | **Repeat**

67

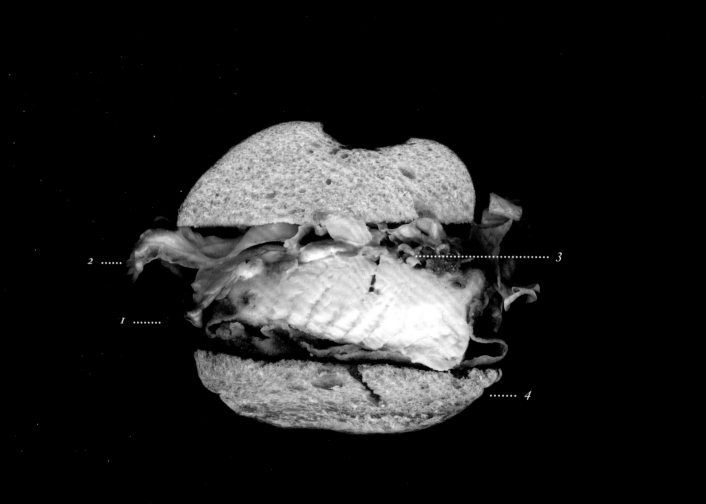

2 ·······

1 ·······

3 ··

4 ········

Fried Fish

1 Fried Fish Fillet, 2 Iceberg Lettuce, 3 Tartar Sauce, 4 Roll

Something Fishy

It's hard for fast food fish sandwiches. Drive-thru menus are packed with a half-dozen burger combinations and almost as many Chicken sandwiches. The lonely Fried Fish sandwich, if it's on the menu at all, sits like a neglected child at the end of the chicken row.

But it's hard to feel too sorry for fast food fish sandwiches. Fish, in general, is something people approach with caution. It's one of the few meats in our industrialized age that's still caught in the wild. It's also a meat that spoils quickly. Anyone who has had a bad piece of fish doesn't forget it. So you can't really blame people who avoid them at establishments that usually have a rack of food already waiting when you pull up.

It's a shame, really, because a good Fried Fish sandwich easily compares to any chicken, beef, or ham option. Batter-fried fish on a crusty bun with some lettuce and tartar sauce is like a tiny piece of heaven by way of the sea. They key, like any seafood, is to select the freshest, moistest fillets. The Fried Fish sandwich may be the neglected child of the fast food world but that's OK. It's too good for them anyway.

Atlantic Cod

Walleye

Key Ingredient | Fish

When selecting fish for your own homemade Fried Fish sandwiches, the best indicator of freshness is smell. The freshest fish smells like a clean ocean or river. The characteristically fishy smell people associate with the food develops as the fish begins to spoil. When buying frozen fish, look for the "frozen at sea" label. This means it was frozen within hours of being caught and the flavor may even be better than fresh fish.

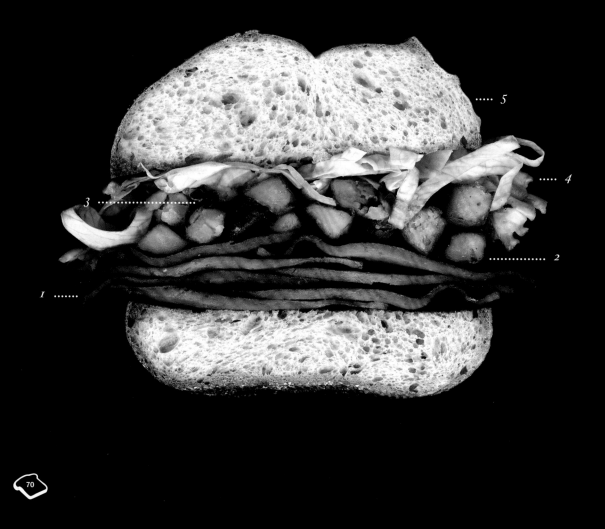

Gatsby

1 Fried Bologna, 2 Chips, 3 Ketchup, 4 Iceberg Lettuce, 5 Roll

The Great Gatsby

Sandwiches are often named after their inventors (Barros Luco, Elvis), and sometimes even their inventor's nickname (Bauru). More rarely they're named after a fictional inventor (Dagwood). The Gatsby may be one of the only sandwiches named after a fictional character who played no role in its invention at all.

In 1976, a Cape Town fish-and-chip shop owner named Rashaad Pandy ran out of fish one day. Desperate to feed a group of day laborers he hired, Pandy filled a round loaf with chips (fries), bologna, and a few other ingredients he had lying around. After frying the sandwich, a worker shouted "This is fantastic—a Gatsby smash!" "Smash" was a local term for tasty dish and the 1974 film *The Great Gatsby* was screening in town, and the guy must have liked it. A lot more people liked the sandwich, and over the years it spread across Cape Town, the name Gatsby following it wherever it went.

Thus F. Scott Fitzgerald's lovesick bootlegger gained another footnote of notoriety and South Africa gained a tasty, homegrown sandwich.

Key Ingredient | **Hot Chips**

Gatsbys are popular today, usually served on foot-long soft rolls with a wide range of ingredients. Chips remain the only requirement.

I *2*

Grilled Cheese

1 Cheddar, 2 Buttered White Bread

Welcome Home

There's something genuinely comforting about a Grilled Cheese sandwich. Maybe it's the light, golden color of the bread and the creamy, womb-like warmth of the cheese. Maybe it's the bond of the two ingredients, the way they come together, almost hugging, impossible to divorce. Maybe the way it's prepared—carefully watching so it doesn't burn, flipping it at just the right time—creates a Zen moment when problems briefly melt away in time with the cheese.

A Grilled Cheese sandwich isn't usually ordered in restaurants. It's not the kind of thing most people feel like eating when other, more complicated and grand options are available. No, the Grilled Cheese sandwich is the meal of home. It's the sandwich of an afternoon returned from school, the late night meal back from the office, or the sick day on the couch paired with a cup of tomato soup. A Grilled Cheese sandwich provides profound comfort and nourishment in one soft, warm, easy to hold package.

Origin | **Unites States**

The availability of pre-sliced bread and easily melted Kraft Velveeta in the 1920s made the Grilled Cheese an instant hit.

Variation | **Ham**

What's the only thing better than a Grilled Cheese sandwich? A Grilled Ham and Cheese sandwich.

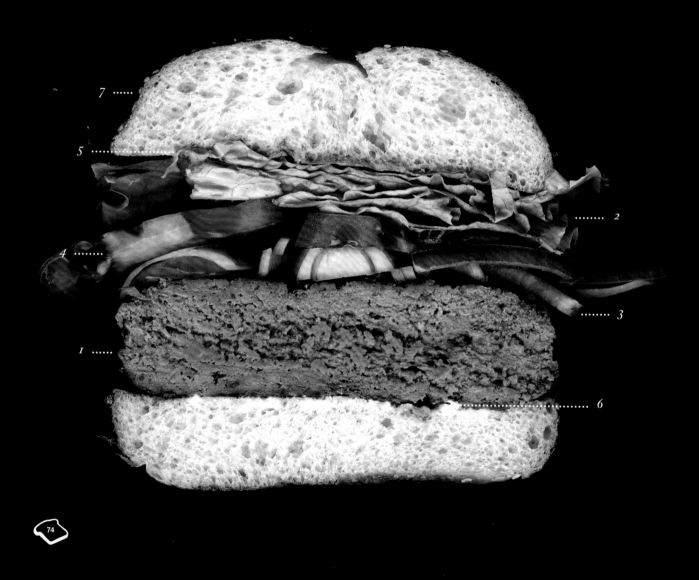

Hamburger

1 Ground Beef Patty, 2 Lettuce, 3 Onion, 4 Tomato, 5 Ketchup, 6 Mayo, 7 Sesame Seed Bun

American Sandwich

The Hamburger stopped being just a sandwich long ago. Sometime around the mid-twentieth century it became a symbol of America, for better or worse.

In the hands of businessmen like McDonald's Ray Kroc it gave birth to the modern fast-food industry, in the process spreading a constant reminder of American influence abroad. Back at home, it fed a nation craving beef, fueling the creation of factory farms as supply raced to keep up with demand. Depending on who you are, the Hamburger can represent ingenuity or greed, freedom or tyranny.

No other sandwich has to deal with so much baggage. Fortunately the Hamburger can take it. No matter how you view it ideologically, that feeling disappears as soon as you bite into one. There is a reason it was exported so well, after all: It's a tasty sandwich.

Variation | **Turkey Burger**

Variation | **Portobello Burger**

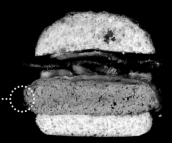

Variation | **Cheeseburger**

The Hamburger as was first created around the turn of the twentieth century but it took over 40 years before the idea of adding cheese caught on.

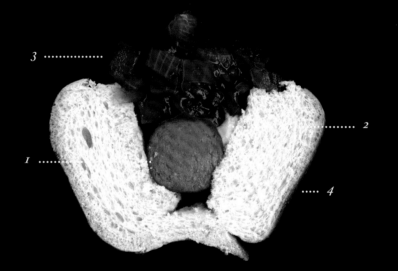

3 ·················

2 ·········

1 ······

····· 4

Hot Dog

1 Boiled Wiener, 2 Mustard, 3 Ketchupy Onions, 4 Hot Dog Bun

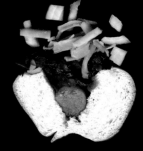

Variation | **Chili Dog**

A Loyal Dog

There are few things more American than the Hot Dog. It's the meal of choice at all our most patriotic events including baseball games, 4th of July BBQs, and state fairs. It's our iconic street meat, available in a cart or stand for us whenever we're hungry.

As iconic and ubiquitous as it is, the Hot Dog is also the butt of jokes. The name "dog" comes from a popular nineteenth-century knee-slapper about the fate of missing pets. The song "O' Where O' Where Has My Little Dog Gone" is actually a morbid ditty about a young boy bemoaning a lost puppy while eating a sausage. Punch line: The puppy's in the sausage.

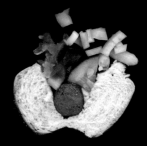

Variation | **Chicago Style**

Today's franks are most assuredly dog free. But like any other great American tradition, people continue to joke about what goes in. In some ways, snarking on Hot Dogs is as much a tradition as eating them at ball games.

Substitution | **Milwaukee Brat**

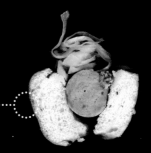

Every region has a Hot Dog breed of their own. Some even adopt a different species, entirely. In Milwaukee ballparks they often swap the usual frank with the bigger, badder German brat.

77

I *2*

Ice Cream

1 Strawberry Ice Cream, 2 Chocolate Cookie Wafer

A Cold Mess

A staple of hot summer days, the Ice Cream sandwich seems like an easy solution to the mess melted confectionery presents. Unfortunately, placing the frozen treat between cookie wafers actually creates a whole new problem as the Ice Cream softens and pushes from between the wafers.

Once a sandwich is pulled from the freezer it becomes a race against the clock. On the hottest days the ice cream can squash out in as little as a minute. Different strategies exist for handling this situation. There's the "side lick" where one runs their tongue around the edge of the sandwich ahead of the melting ice-cream. It works but you end up with two cookie wafers and no ice cream in the end. You can also wolf it down, risking brain freeze for the sandwich's sake. The third option is to accept your sticky fate and remain confident that there will be a pool or sprinkler nearby to wash away the mess before the bees show up.

Most sandwiches solve the problem of eating messy foods in a clean, one-handed fashion. Ice Cream sandwiches may be the only ones that makes it messier.

Origin | **United States**

Some of the earliest Ice Cream sandwiches were sold by New York City street vendors around the turn of the twentieth century. Today's ice cream trucks and convenience store freezers continue their tradition of providing cold ice cream relief on hot summer days.

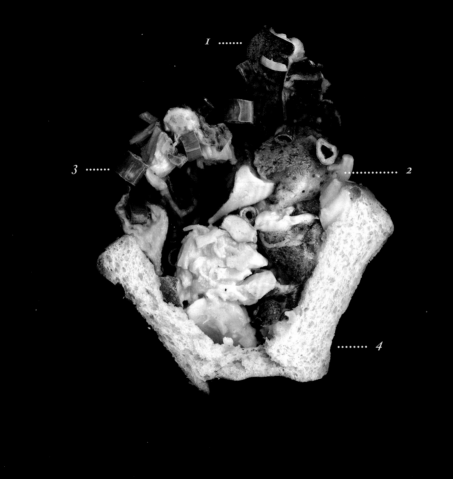

Lobster Roll

1 Boiled Lobster, 2 Mayo, 3 Green Onions, 4 Top-Loader Hot Dog Bun

New England Summers

Growing up in Central Texas, I was unprepared for my first Lobster Roll experience. It was summer and I was visiting my girlfriend's family in New Hampshire. We were at a seafood restaurant on the state's tiny stretch of coastline and we ordered Lobster Rolls. The entire meal was like a religious experience, a sensation out-of-state Lobster Rolls have never matched.

The quintessential New England summer snack, the Lobster Roll is rare outside the Northeast. Anyplace else, lobster is too expensive and luxurious to put in a sandwich. It's all for the best. Some things are so entwined with a place and time that divorcing them destroys their power. New England summers and Lobster Rolls are one such pair.

Sandwich Tool | **Crackers**

If you want to boil your own lobsters it's important to have the right tools. Claw crackers are essential. Nut crackers, like these, work in a pinch.

Variation | **Connecticut Style**

The Connecticut style roll consists of hot lobster and drawn butter. Invented the 1930s by Harry Perry, a restaurateur in Milford, Connecticut at the request of a traveling salesman, the style was once the more common roll. Today it's found very few places outside of Connecticut.

81

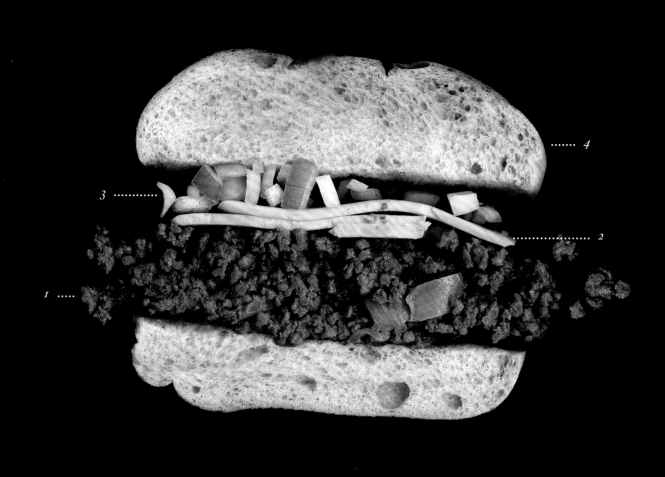

3 ⋯⋯⋯⋯

4 ⋯⋯⋯⋯

2 ⋯⋯⋯⋯⋯⋯⋯⋯⋯⋯⋯⋯⋯

1 ⋯⋯

Loosemeat

1 Ground Beef, 2 American Cheese, 3 Onions, 4 Hamburger Bun

One Sandwich, Three Names

Somewhere between a Hamburger patty and a sauce-drenched Sloppy Joe, sits Iowa's Loosemeat sandwich. The ground beef in a bun is a popular meal across the Midwest, but it may be difficult for out-of-towners to nose out. The sandwich goes by not one, but three, aliases.

Besides Loosemeat, another name you might hear is "Maid Rite." In 1926 Fred Angell, a butcher in Muscatine, Iowa, put a Loosemeat together. After giving it to a delivery man to try, the man responded "You know, Fred, this sandwich is just made right." Eighty-six years later dozens of Maid Rite franchises are still selling their eponymous sandwich across the Midwest.

Tavern sandwich, the third moniker, is derived from a competing origin story across the state in Sioux City where the Ye Olde Tavern Sandwich Shop was thought to have first offered the sandwich in the 1930s.

Wherever you find it, whatever it's called, it's a filling sandwich that any hungry traveler will find worth tracking down.

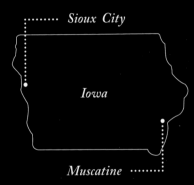

Sioux City

Iowa

Muscatine

Origin | Hawkeye State

Whatever name it goes by, the Loosemeat sandwich is a proud Iowa native. All origin stories point to the 29th state.

Marmite

You Love It or You Hate It

Of all the ingredients in this book, perhaps none is more polarizing than Marmite. The sludge left over from brewing beer (they call it "yeast extract"), Marmite is a thick, salty, powerfully flavored substance that some people love and others abhor.

It's mighty stuff, but when used sparingly on a sandwich, it has a way of making two slices of toast turn into an entire feast of flavor. Rich in the B vitamins, it also acts as multi-v between bread. Lastly, it's persistent stuff—one jar used daily can endure for months.

I confess, I love Marmite. More than once my girlfriend has come home early from work to find me on the couch licking it off a knife. It's a boisterous and obnoxious spread but it's not without its charms. If you love Marmite, it has a way of returning the favor.

Ingredient | **Marmite**

Popular in the U.K., Marmite has capitalized on its polarizing reception with an ad campaign using the slogan *love it or hate it*. In Australia, Marmite's fraternal twin, Vegemite, is equally divisive.

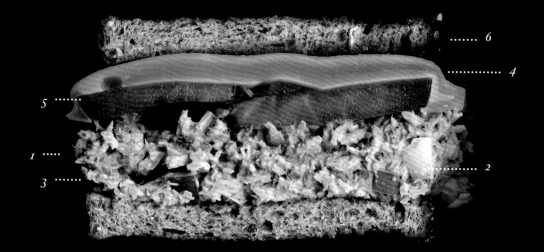

6

4

5

1

2

3

Melt

1 Tuna, 2 Onions, 3 Mayo, 4 Swiss, 5 Tomato, 6 Multigrain Toast

Cheese Please

Many sandwiches use cheese as an ingredient. Melts make a point of using it in abundance.

"Melt" can be used to describe any sandwich that melts cheese over a key ingredient such as tuna, turkey, beef, or veggies. What differentiates a Melt from other sandwiches is the amount of cheese used and the attitude with which it's applied.

In a good Melt the cheese binds the whole sandwich together without overwhelming the star ingredient. It's a careful balancing act between meat and cheese with neither taking complete control. Warm cheese drips out from the side, infusing the rest of the construction with its rich, creamy taste. Meanwhile the meat accepts the warm embrace, confident that it will be the juicy, savory center to the sandwich.

Ingredients alone can't really be used to describe a Melt, its just a feeling. You know a melt when you see it.

Variation | Patty Melt

A beef patty + cheese. *Patty Melt* is also the name of a mascot used by the Pennsylvania Beef Council to promote beef consumption. You'll recognize her if you see her too, she's a Patty Melt with a face, pink hat, and braids.

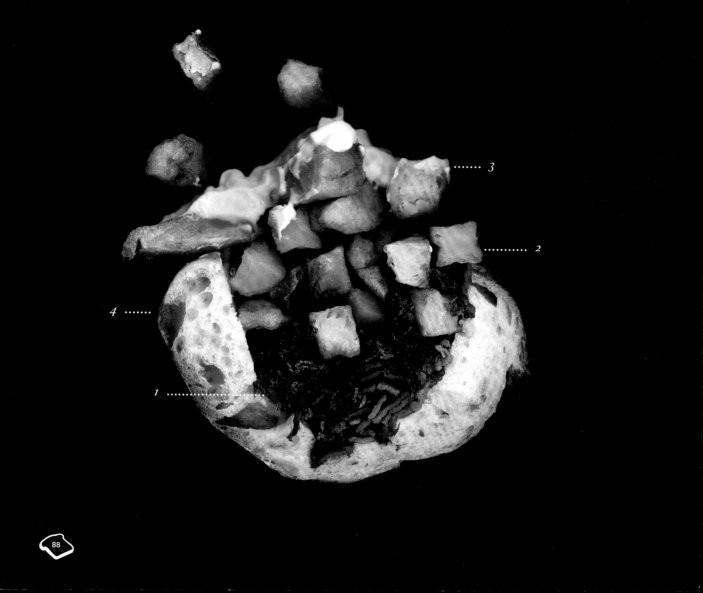

Mitraillette

1 Fried Beef, 2 Fries, 3 Mayo, 4 Baguette

The Belgian Terror

The Mitraillette is a bit of an intimidating sandwich. It's hard to keep your courage up when facing a whole baguette filled with fried meat, packed to the breaking point with fries, and then coated in sauce.

It shouldn't come as a shock then, that the Mitraillette is a favorite late night snack of bar-hopping Belgians who have consumed just enough liquid courage to transform the frightening creation into a mouth-watering meal.

You don't always have to be intoxicated to face a Mitraillette. It's a popular snack for drinkers and teetotallers alike. Being deliriously hungry certainly helps, though.

Name | **The Machine Gun**

Even the name *Mitraillette* sounds threatening, and it should, it translates to *Submachine Gun* in French. Not the kind of thing you casually put near your face.

89

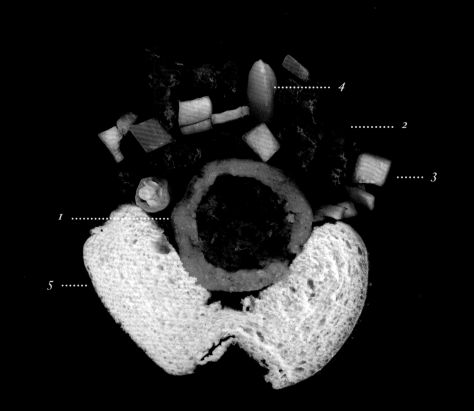

Mother-in-Law

1 Beef Tamale, 2 Chili, 3 Onions, 4 Sport Peppers, 5 Hot Dog Bun

A Tamale in a Sandwich

There's a joke that asks, "What's in a Mother-in-Law sandwich?" Answer: cold shoulder and tongue (cue rimshot). But there is a real sandwich called the Mother-in-Law that's popular on Chicago's South Side and while it doesn't have cold shoulder and tongue, its actual ingredients are just as strange.

In a Mother-in-Law you'll find a beef tamale, covered in chili, nestled in a Hot Dog bun. It being Chicago you may also find some pickles, onions, relish, and peppers on top.

The sandwich's name and origin are complete mysteries. Some theories claim it originated in the Mississippi Delta, where tamales are a popular snack. Others point to a large Mexican population in Chicago as a possible source. Corn meal mush was also a common meal in Illinois during the late-nineteenth/early-twentieth century, so that might be a third explanation.

With so many questions asked but left unanswered, eating a Mother-in-Law can be a fascinating and thought-provoking experience.

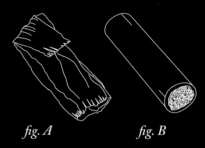

fig. A *fig. B*

Ingredient | Tamale

Traditional tamales (*fig. A*) are often made by hand and come wrapped in corn husks. Mother-in-Law sandwiches use a style of tamale unique to the Midwest (*fig. B*). The husks and handmade preparation are gone, instead the tamale resembles a tubular, meat-stuffed cylinder, the result of being extruded through a machine in a factory.

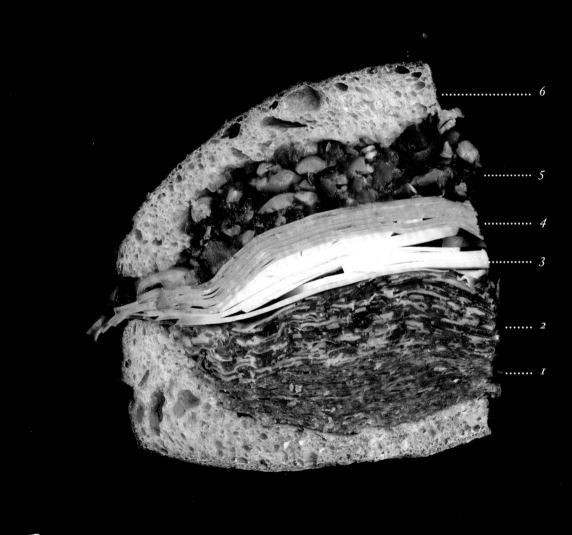

6

5

4

3

2

1

Muffaletta

*1 Salami, 2 Capocolla, 3 Provolone, 4 Mortadella,
5 Giardiniera and Olive Salad, 6 Hollowed, Round Italian Loaf*

The Big Meaty

New Orleans is known for many things, among them, big
personalities, voodoo magic, and southern hospitality. The
Muffaletta is a New Orleans sandwich that has a little bit of each.
The Muffaletta was created by Salvatore Lupo, owner of Central
Grocery, to feed the hungry farmers selling their goods in the French
Quarter. The farmers would order items piecemeal, a little ham
here, a bit of bread there. To Salvatore this seemed like an inefficient
way to make a lunch. To satisfy these hungry mouths and make
it easier to eat, Lupo took a large round loaf of bread and filled it
with the ingredients he had at hand. Thus the Muffaletta was born.
The sandwich is still made and served at Central Grocery today,
conjuring up lines that wrap around the block come lunchtime.

Ingredient | Muffaletta Filling

Muffaletta may take its name from the Sicilian word for soft loaf (*muffuliette*),
but its filling (made up of olives, herbs, giardiniera, and oil) is the otherworldly
element. Let it sit over night and it becomes supernaturally delicious.

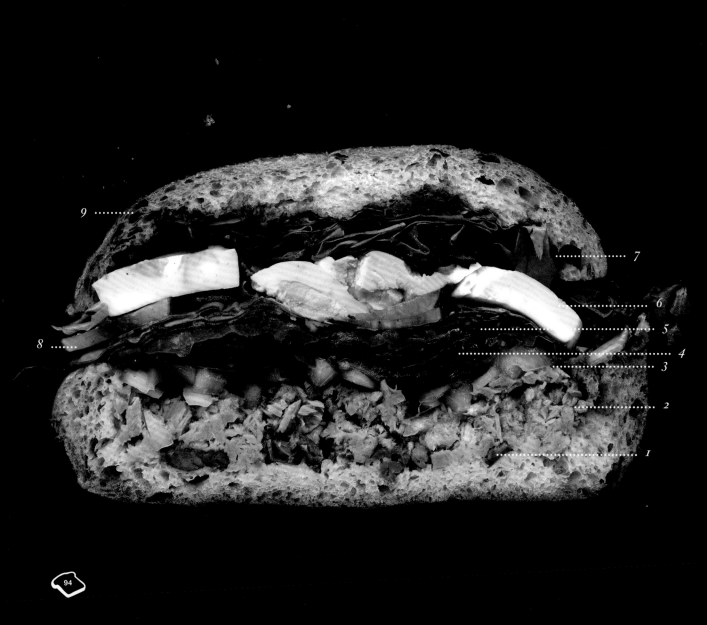

Pan Bagnat

1 Niçoise Olives, 2 Tuna, 3 Onions, 4 Tomatoes, 5 Anchovies,
6 Hard Boiled Eggs, 7 Lettuce, 8 Radishes, 9 Hollowed Loaf

Worth the Wait

Most sandwiches are meals of convenience; quick snacks
that you eat, or rapidly assemble, as soon as hunger strikes.
The Pan Bagnat, a hollowed-out loaf filled with olives,
sardines, and tuna, is not one of those sandwiches.

All good things are worth waiting for, and a Pan Bagnat is no
exception. To make one right you need patience. After assembling
the ingredients, you have to give them time to soak in and let the
flavors meld together. A few hours is the minimum, overnight
is best. It really depends on how long you think you can wait.

Common throughout Europe, Pan Bagnat is most popular in
Nice, the land of its origin. The people of Nice are proud of
their cuisine, especially the Pan Bagnat. In 1991 a "Commone
Libre du Pan Bagnat" was formed to defend and promote the
sandwich's tradition against outside competition including
that fast food heavyweight, the American Hamburger.

Name | **Wet Bread**

Pan Bagnat means *Wet Bread*
in the Provençal dialect of Niçard
and is an apt description of the
sandwich when properly made.
Here is a loaf before being filled.

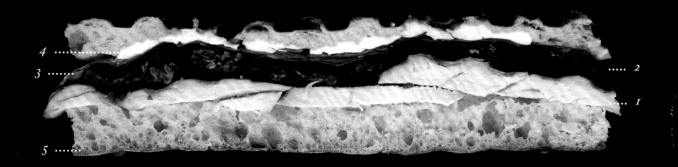

4
3
........ 2
........ 1
5

96

Panini

1 Grilled Chicken, 2 Sun-Dried Tomatoes, 3 Spinach,
4 Feta, 5 Grilled Ciabatta Bread

So Hot Right Now...

The Panini is a modern-day sandwich phenomenon. One of the most popular and globally successful foods of the past decade, the Panini has made the sandwich vogue like never before.

Maybe its striking black lines and svelte shape catch the eye better than unpressed sandwiches. Maybe it's the name? Panini. It sounds so stylish and high-brow, compared to the boorish Grinder, Hoagie, and Po' Boy. Its roots are fashionable as well, akin to luxurious Italian fashion houses. Toasted Panini were common in Italy for much of the twentieth century and were especially popular with the youth, nicknamed "Paninari," who were too active to sit for meals, scarfing the pressed sandwiches as they went about doing trendy things.

How can a sandwich with such a great figure, name, and pedigree not become a sensation? The Panini is the sandwich du jour and a common site in stylish cafes and bistros worldwide.

Variation | **Nutella and Strawberries**

Variation | **Roast Beef and Peppers**

One reason the Panini is so popular is that it's really just a preparation style. Any combination of ingredients and bread that can go into a press will emerge a Panini. That flexibility means there's a Panini for every taste.

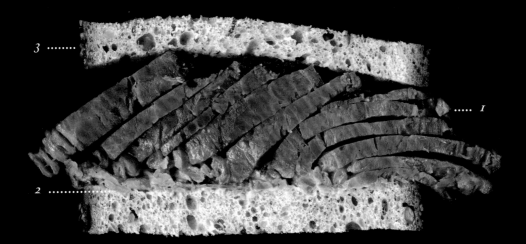

Pastrami on Rye

1 Beef Pastrami, 2 Deli Mustard, 3 Sliced Rye

Save the Pastrami

Pastrami on Rye is a classic Jewish delicatessen all-star. Institutions like New York's Katz's have become sandwich meccas on the strength of nothing more than a little deli mustard, some crusty rye, and a mountain of pastrami. Tragically though, really good pastrami, and the quintessential Jewish deli, are slowly vanishing from the American landscape.

Brought to New York by Romanian immigrants, pastrami is brined, spiced beef brisket smoked and then steamed (sometimes more than once) before being served. Deli pastrami is often a rich, greasy, melt-in your mouth sensation that works best on a sandwich. It's an experience that's becoming harder to find. Even the site of my parents' first date: Austin, Texas' Katz's Deli (no relation) was forced to close because they were in grim financial straits.

Some delis endure. New York's Katz's is packed most weekends with dozens of ticket holders waiting for a savory meal. But as more and more delis disappear, it stands to be seen if places like Katz's will spawn a Renaissance or become reduced to sanctuaries, the last protected areas of a once widespread pastrami beast.

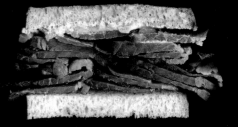

Variation | Montreal Smoked Meat

Similar to the Pastrami on Rye, the Montreal Smoked Meat sandwich is an equally rich, moist, and endangered experience.

99

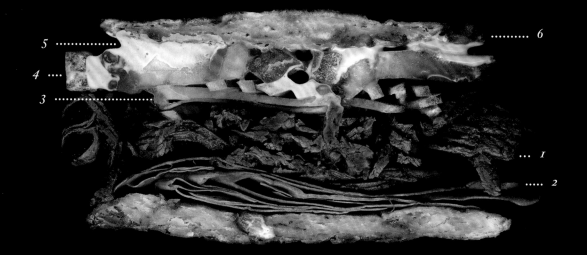

Patacón

Who Needs Bread?

Is a sandwich without bread still a sandwich? The Venezuelan Patacón certainly prompts that question. There's no bread to be found on a Patacón. Instead meat and veg are held between two plantains, sliced length-wise, smashed, and deep fried into patties.

The fried plantains are a better replacement for bread than one might expect. Served while the patties are still hot, a Patacón can contain pork, beef, chorizo, chicken, or cheese. The sweet, starchy flavor and unique texture of the plantain may be alien and exciting experience for the unfamiliar. However, by the end of the meal you're left wondering why more sandwiches don't stray from the bread-crumb trail.

Born in the Venezuelan city of Maracaibo, Patacóns can be found few places outside Latin America. Where it does pop up, the breadless sandwich develops a devout following of plantain enthusiasts.

Ingredient | **Plantain**

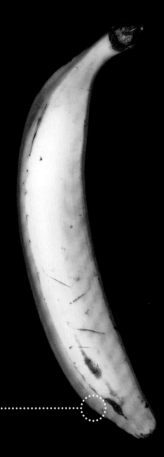

The sweet starchy cousin to the banana that, after smashed into patties and fried, forms the patacon's bread.

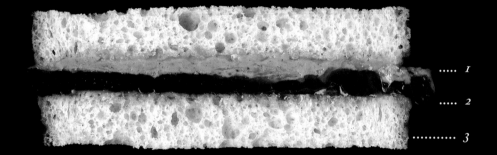

..... *1*

..... *2*

........... *3*

PB&J

A Match Made in Heaven

Few things pair as well as peanut butter and jelly. A popular meal with children and adults worldwide, the sandwich has the twin virtues of being tasty and cheap. However, that wasn't always the case.

For decades peanut butter was expensive and obscure. Considered a delicacy and only served in the most posh situations, it was combined with beef, Worcester sauce, and other odd pairings without any of them catching on. Its health benefits were being touted by the likes Dr. Kellogg and revolutionary scientists like George Washington Carver were investing a lot of time into the plant, but it needed something more to take off.

Somewhere around 1900 jelly met peanut butter and both their lives changed forever. A few decades later sliced bread entered the scene and married the two forever in a sandwich embrace.

Ingredients | **Peanut Butter & Jelly**

The two perfect partners just before union. Separate knives are a must for finicky types that don't like J in their PB jar or vice versa.

103

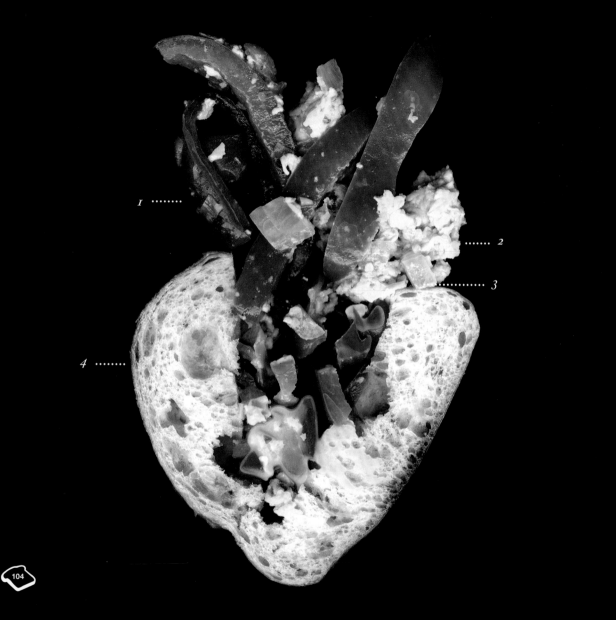

Pepper & Egg

1 Softened Peppers, 2 Scrambled Eggs, 3 Onions, 4 Ciabatta

Lenten Lunch

For devout Catholics, Ash Wednesday marks the beginning of Lent, six weeks of abstaining from, among other things, meat, until Easter Sunday.

For many this means that usual lunch items like deli sandwiches are off the menu. Fortunately, while abstinence forbids the use of meat, it does not restrict the use of eggs or dairy, making the delicious Pepper & Egg sandwich 100% Lent approved.

A common Lenten lunch for generations of Italian-Americans, the Pepper & Egg sandwich hardly seems like a sacrifice. The warm, garlic-infused mix of scrambled eggs and softened bell peppers is something many people choose even when meat is an option, and it can be found on the menu, year-round, at many classic Italian sandwich shops and pizzerias. A great meal, Catholic or not, the Pepper & Egg hero is a sandwich that knows no creed.

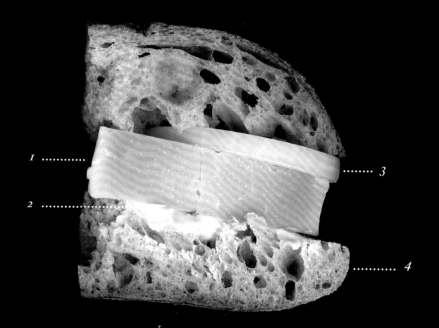

1

2

3 3

4 4

106

Ploughman's Lunch

Cheese, 2 Butter, 3 Onion, 4 Crusty Bread

Proto-Sandwich

A Ploughman's Lunch is a popular snack in the U.K. Generally composed of a piece of cheese, a hunk of buttered bread, and something pickled, the Ploughman's Lunch is not explicitly a sandwich. However, what earns the ploughman's lunch a place in this book is the opportunity it presents to the eater.

A Ploughman's Lunch is an assemblage of raw ingredients placed before you. It doesn't come with a set of instructions or an established etiquette for how to eat it. Some people tackle each ingredient separately taking a bite of cheese, then a bit of bread. But others show a little more creativity: They put the cheese between the bread and enjoy their meal as a sandwich.

The choice that eater makes, whether to eat the ingredients separately or combine them together, is the same choice less noble ancestors, maybe ploughmen themselves, likely made hundreds of years ago, long before the 4th Earl of Sandwich got his greasy mitts, and name, on the assemblage.

Ingredients | Cheese & Bread

Whether ploughmen actually ate such a lunch is a matter of speculation. However, a good bit of cheese and some nice crusty bread is a lunch worthy of any occupation.

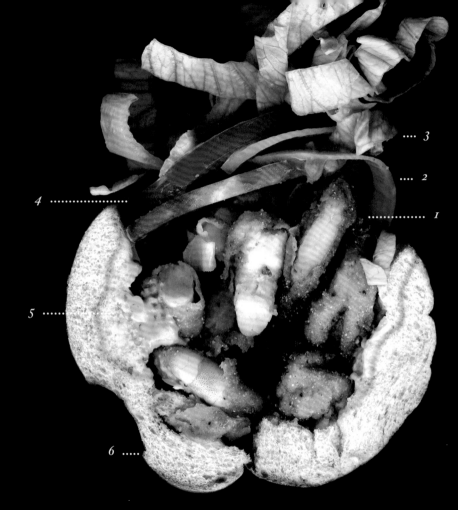

.... *3*

.... *2*

4

.............. *1*

5

6

Po' Boy

1 Fried Shrimp, 2 Onion, 3 Lettuce, 4 Tomato, 5 Mustard, 6 Roll

The Poor Boys' Sandwich

Usually filled with fried fish, shrimp, or shellfish, the Po' Boy sandwich is Louisiana's version of the ubiquitous Sub (p. 132). The origin of the name, like many sandwiches', is disputed. However, one of the best documented is also the most interesting.

In 1929, New Orleans ground to halt after 10,000 transit workers went on strike, protesting a decision to convert all city streetcars into buses, an act that would put many of them out of a job. A botched police attempt to break up a group of protesters resulted in several deaths and hundreds of injuries. In response to the violence, two former streetcar employees turned restaurant owners, Clovis and Bennie Martin, offered free sandwiches at their French Market cafe to any "poor boy" coming in from the protest. Just to make their support crystal clear the brothers added, "We are with you till Hell freezes over, and when it does will furnish blankets to keep you warm."

Free sandwiches are a powerful bargaining tool. The protesters won. Streetcars still operate in New Orleans today and are now considered a city icon. Another icon, Po' Boys, are also around, available to any person protesting a growling stomach.

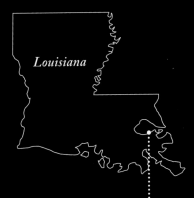

Louisiana

Origin | **New Orleans**

The Po' Boy's hometown and a historic French colony. Another theory regarding the etymology of the name suggests it derives from the French word for tip, **pourboire.**

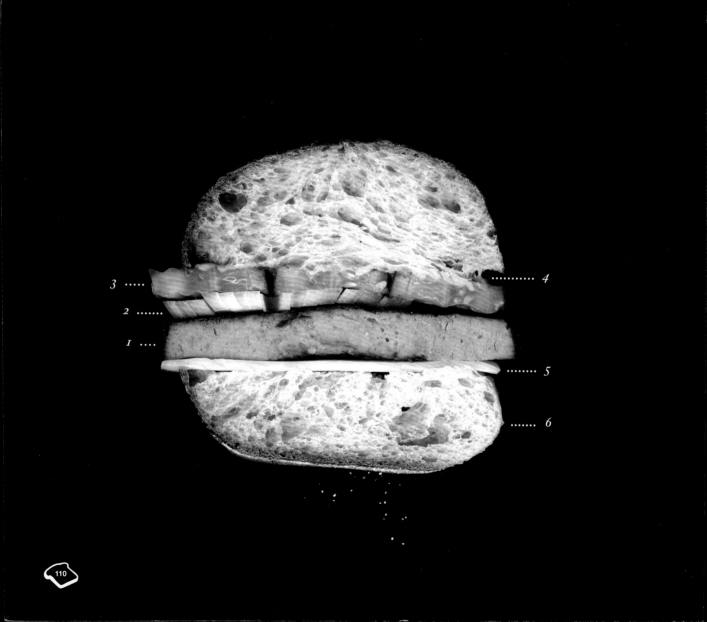

3 ······ 4

2 ·······

1 ····

5

6

Porilainen

1 Sausage Slice, 2 Onion, 3 Pickle, 4 Mustard, 5 Swiss, 6 Bun

The Finnish Hot Dog Burger

The Scanwiches pun wouldn't be complete without a *Scan*dinavian sandwich. Enter Finland's Porilainen.

Like a cross between a Hamburger and a Hot Dog, the Porilainen takes a fat slice of thick sausage, grills it, and places it between a bun. Pickles, cheese, mayo, and other ingredients find their way in as well.

A hearty street food, the Porilainen is a welcome export from a region better known for open-faced sandwiches than the proper "closed" variety.

Ingredients | **Large Sausage Slice**

The sausage in a Porilainen is very similar to a hot dog. Meat pureed to the same consistency goes into both. However, in a Porilainen the resulting sausage is much bigger. The sliced section that goes onto a bun is comparable in size and shape to most hamburger patties. For those looking to make one at home, request an inch-thick slice of bologna from a deli then grill it as you would a burger.

+

=

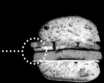

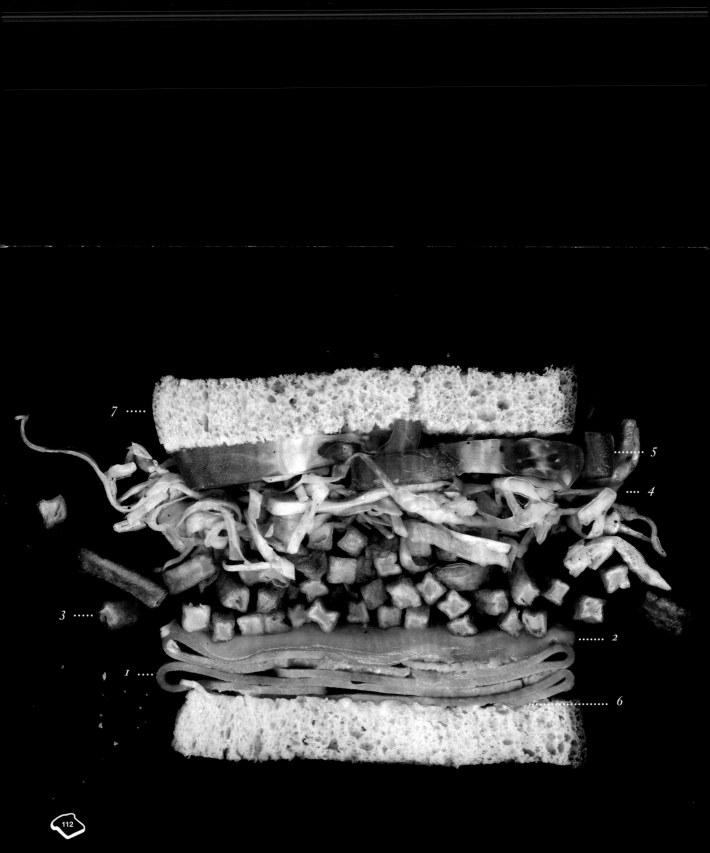

7

5

.... 4

3

........ 2

I

................ 6

112

Primanti Brothers

1 Ham, 2 Swiss, 3 Fries, 4 Coleslaw, 5 Tomato, 6 Mayo, 7 Bread

Pennsylvania's Other Famous Sandwich

Pittsburgh has a bit of a problem. Its name is Philadelphia. Home of the Liberty Bell and Rocky, Philly has consistently relegated Pittsburgh to second-city status. It's even thrust its Cheesesteak into the national spotlight, blinding many to the amazing meal Pittsburgh calls its own, the Primanti Brothers sandwich.

First made in the 1930s, at the original Primanti Brothers location in Pittsburgh's Strip District, the coleslaw, meat, and french fry sandwich was conceived of as an entire meal between bread. The sandwich easily lives up to its billing. It is a behemoth, piled high with ingredients and two thick slices of Italian bread. One sandwich is usually more than enough to satisfy a hungry diner.

Pittsburgh may play second fiddle, but it gets the last laugh. Consistently ranked one of the most livable cities in the nation and aggressively investing in new industries, Pittsburgh is a city with goals and home to a sandwich that makes the Cheesesteak feel a little unambitious.

Ingredient | Fries

Legend says the whole meal-in-a-sandwich concept came about after the original Primanti brothers ran out of plates, forcing them to put the usual sides (fries and coleslaw) in the sandwich.

113

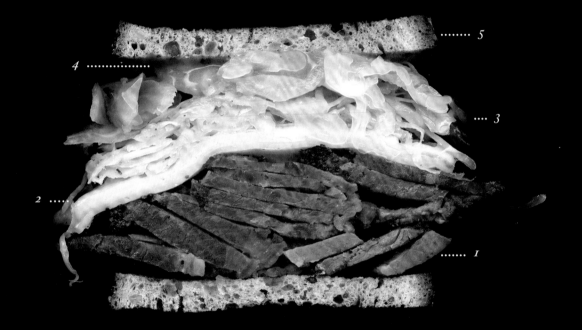

5

4

3

2

1

114

Reuben

1 Pastrami, 2 Swiss, 3 Sauerkraut, 4 Thousand Island Dressing, 5 Rye

Reuben Who?

Many sandwiches are named after people, and the Reuben is one of those sandwiches. When you start asking who exactly the Reuben is named after, however, things get sticky.

Some stories place the creation of the Reuben at the now closed Reuben's Restaurant and Delicatessen in New York. Depending on who's telling it, the sandwich here was either made in the '50s by a businessman in honor of store's founder, Arnold Reuben; a chef in the '20s, who felt that Arnold Reuben Jr. ate too many hamburgers; or by Arnold Reuben himself in the '10s for a leading actress named Annette Seelos.

If that weren't confusing enough, there's another fellow named Reuben Kay, a grocer from Omaha, Nebraska, who may have created the sandwich between 1920 and 1935. Kay's Reuben was on the menu exclusively at the Blackstone Hotel until 1956 when it won a sandwich contest and gained national visibility.

The definitive answer of who made the Reuben first may never be known. But at least all parties concerned get to have their name on it.

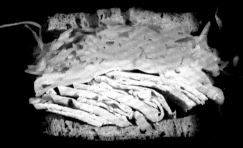

Variation | **Rachel**

The Rachel, a Reuben made with turkey instead of corned beef or pastrami, is actually much closer to Arnold Reuben's first creation, made of ham, turkey, swiss, coleslaw, and Russian dressing.

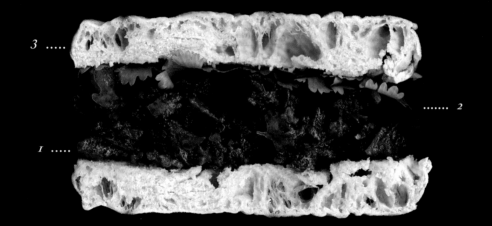

3

....... 2

I

Rou Jia Mo

1 Shredded Pork Belly, 2 Coriander, 3 Pan-Fried Bread

Chinese Hamburger

For much of East Asia, sandwiches are a relatively new phenomenon brought from abroad by the new global economy. In parts of mainland China, sandwich chains like Subway have struggled a bit to establish themselves. Subway opened its first Chinese storefront in 1995, only to find that most Chinese weren't interested in their subs. The ones that did try the snack peeled them apart like a banana. More branches have opened since that day but subs are still a hard sell.

However, China actually does have a native sandwich, although that's not what they call it. Found in the city of Xi'an, 600 miles southwest of Beijing, is a meal known as Rou Jia Mo. Composed of pork, beef, or chicken, spices, and coriander between bread, Rou Jia Mo, when found outside China, is occasionally called the *Chinese Hamburger*.

Rou Jia Mo translates to *Meat Held Between Bread*. With that description in mind there's no reason why we shouldn't enthusiastically include it in the sandwich club.

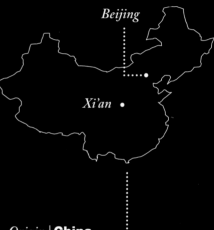

Beijing

Xi'an

Origin | **China**

China is a large nation with a rich diversity of cultures. It's not surprising then that a meal in Xi'an did not resonate with Beijing. It would be equivalent to a Slovenian street food changing palettes in London, England.

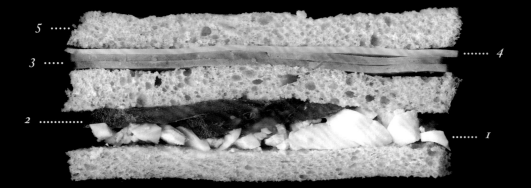

5 ·····
3 ·····
2 ·············
········ 4
········ 1

Sandwich de Miga

1 Egg, 2 Tomato, 3 Ham, 4 Swiss, 5 Crustless White Bread

Argentina's Other Street Sandwich

Argentina, home of the of crusty, hot Choripán (p. 48), is also the birthplace of a sandwich at the other end of the spectrum. The cold, crustless Sandwich de Miga is the yin to the Choripán's yang.

Sandwiches de Miga are not a single sandwich but rather a whole slew of snacks very similar to England's Tea Sandwich (p. 134) and Italy's Tramezzini (p. 140). Filled with a large selection of ingredients, Sandwiches de Miga are often sold in cafes and bakeries by the dozen.

Cheap and light, Sandwiches de Miga are the perfect quick meal for someone who may not be feeling a greasy sausage, and who is looking for a little variety in what they eat between bread.

Name | **Bread Crumb**

Sandwiches de Miga can be filled with a wide array of ingredients from eggs, to meat, to vegetables. They are all crustless, though. *Miga* actually describes the soft center, or *crumb,* of the bread.

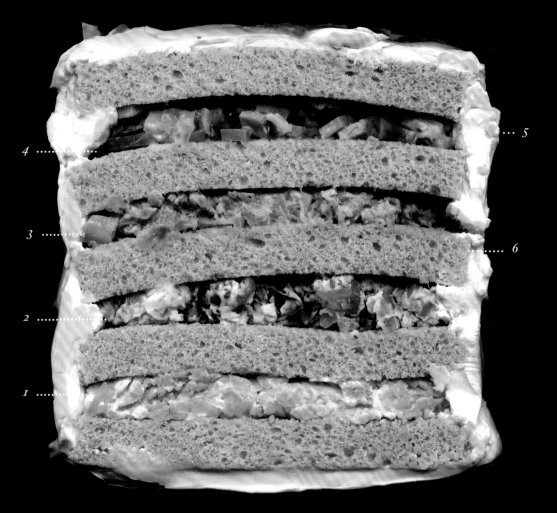

Sandwich Loaf

1 Shredded Cheese Salad, 2 Walnut Salad, 3 Salmon Salad, 4 Ham and Bologna Salad, 5 Cream Cheese, 6 Horizontally Sliced Loaf

Cold War Comfort

The Sandwich Loaf was a popular dish in mid-twentieth-century America, a time when perishing in a global nuclear holocaust was considered a reasonable fear.

Like the rationale behind Mutually Assured Destruction as a peace strategy, the Sandwich Loaf is a head-scratching distortion of the usual sandwich. More like a cake than a anything else, the Sandwich Loaf is made by horizontally slicing a loaf of bread, stuffing the layers with ingredients, and then icing the whole assemblage with cream cheese. Slices are served on a plate and eaten with a knife and fork, a total betrayal of the sandwich.

A popular dish at the time, the Loaf was common at social events and parties. But like many things from the Cold War era, it seems humorous and a little frightening in retrospect. Sandwich Loaves are rarely made today, but are, none-the-less, an important piece of history: A lesson on how close we came to wiping out the sandwich as we know it.

SANDWICH LOAVES
These can even be a meal by themselves—an excellent luncheon dish with coffee and a dessert, and, when made in individual sizes, real charmers. As a decorative center for a birthday buffet, use one large loaf, as shown above; or make an individual loaf for each guest, seen above on the right, and group the loaves around a pile of gaily wrapped gifts.

Archive | **Cookbook Clip**

A scan of my 1980 edition of *The Joy of Cooking*, extolling the virtues of the Sandwich Loaf. It's absent from the current edition.

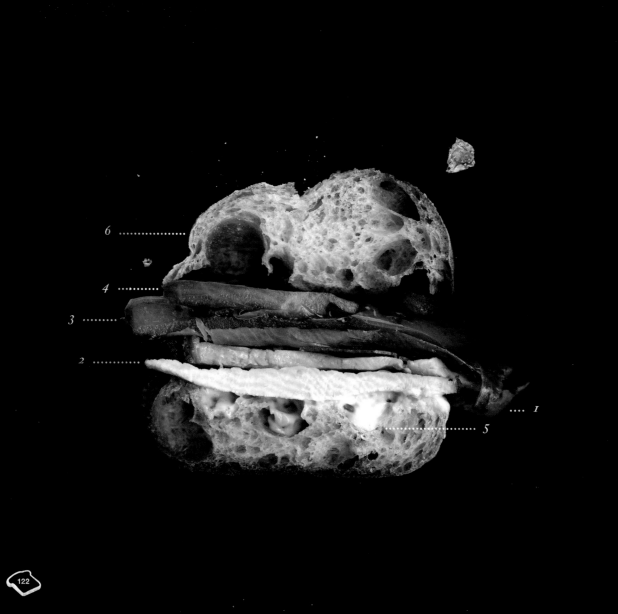

6

4

3

2

.... 1

5

122

Serranito

1 Jamón Serrano, 2 Pork Loin, 3 Fried Green Pepper,
4 Tomato, 5 Aioli, 6 Crusty Bread

A Lesson in Restraint

A Serranito is a Spanish sandwich found primarily in the southern region of Andalusia. Composed of tender pork loin, fried green pepper, and a single slice of dry-cured jamón serrano, the Serranito is a common snack in the cafés and restaurants of Seville.

Unlike many sandwiches, the key to a Serranito is restraint. The single slice of serrano ham is the keystone of the sandwich. The rich, salty quality of the ham carefully balances the rest of the flavors. On any other sandwich, it would be tempting to layer it up, especially if you're hungry. In most cases adding an extra slice of turkey or one more sliver of cheese has no detrimental effect. On a Serranito though, too much jamón can tip the scales, turning the sandwich into salty mess.

The Serranito is a lesson in self-control. Only those who can rein-in their impulses can reap the rewards that the slice of ham delivers.

Ingredient | Single Slice of Jamón Serrano

A single slice of dry cured ham. The sandwich's name, Serranito, is the diminutive form of *serrano*, and a reminder that a little can go along way.

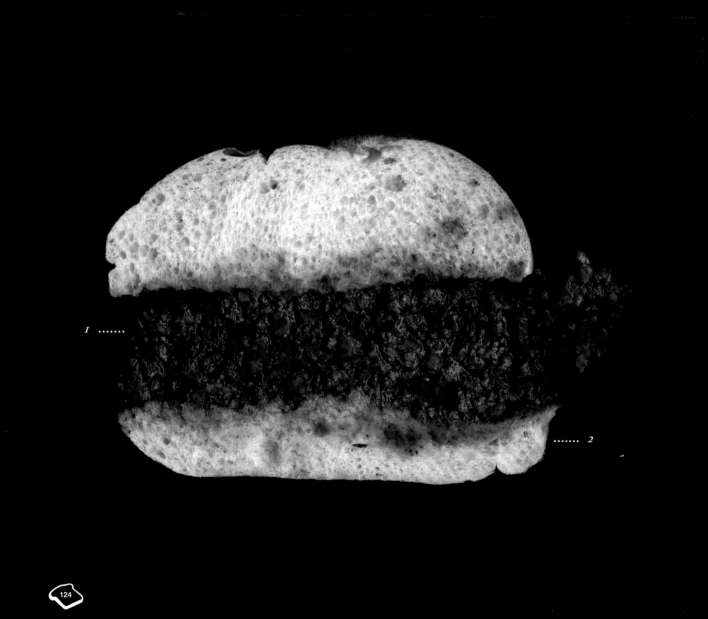

Sloppy Joe

1 Ground Beef and Tomato-Based Sauce, 2 Hamburger Bun

A Hot Mess

A childhood classic, the Sloppy Joe may be the most difficult, but most fun, sandwich to eat.

The point of a Sloppy Joe is not to be neat and tidy, but to be messy; to embrace, rather than resist, that prepubescent desire to ruin clean clothes and washed faces. It's the sandwich whose name warns from the start that a there will be a lot to clean up by the end of the meal.

How it got that name and where it came from is a messy situation of its own. There's a whole slew of theories. One claims it takes it's name from the term "sloppy joe" a once popular description of a dingy diner, what we might call a "greasy spoon" today. Another story names it after a café cook in Sioux City, Iowa. A third links it to a style of large, baggy sweater popular in the forties.

Wherever it came from, the Sloppy Joe is here to stay—and so are the stains it leaves behind.

Origin | **United States**

A weekly regular at school cafeterias for most of the nation, the Sloppy Joe has been a tasty and cheap way of stretching meat out since the Great Depression.

125

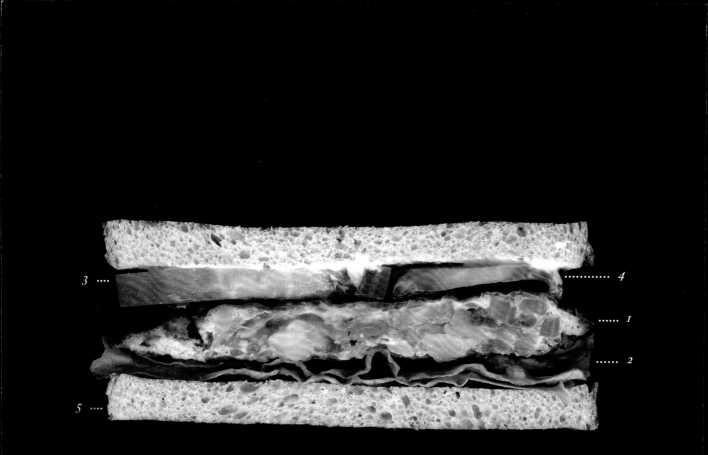

St. Paul

1 Shrimp Egg Foo Young, 2 Lettuce, 3 Tomato,
4 Mayo, 5 White Bread

The Melting Sandwich

Commonly found around St. Louis, Missouri, the St. Paul is composed of an egg foo young patty between two slices of white bread.

The origin of the patty, and egg foo young itself, is a bit complicated. Invented in America in the late nineteenth century by either Chinese immigrant cooks or a New York cook serving a Chinese emissary, it's a uniquely homegrown ethnic food as authentically Chinese as fortune cookies and as American as apple pie. Simultaneously a child of China and the United States, but belonging wholly to neither, egg foo young was a popular style of Chinese-American food through the end of the twentieth century. The St. Paul takes that cultural mash-up even further and puts it all on a sandwich, adding a little lettuce, mayo, and tomato for good measure.

Some say the United States is a melting pot, others say it's more of a chunky stew. I like to think it's a sandwich—and that sandwich probably looks something like a St. Paul.

St. Louis

Missouri

Origin | St. Louis

The St. Paul sandwich is a fixture of St. Louis cuisine, available in many Chinese food take-out joints. Why it's called a St. Paul is a bit of mystery. Some theories claim it was invented by a cook from St. Paul, Minnesota, but the truth may forever remain a mystery.

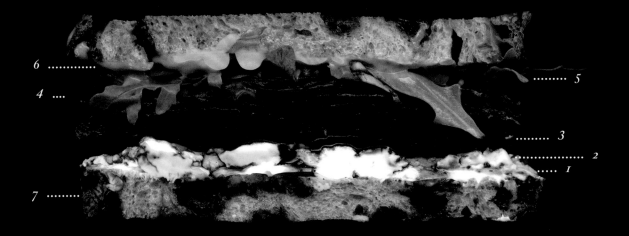

6

4

6 5

4 3

2

1

7

Stalwart Goatherd

*1 Goat Cheese, 2 Honey, 3 Roasted Beets, 4 Roasted Red Pepper,
5 Arugula, 6 Roasted Garlic Spread, 7 Whole Wheat Raisin Nut Bread*

We Have a Winner

The Stalwart Goatherd, a sublime rush of honey, goat cheese, and beets between raisin nut bread, was the winner of the *Scanwiches* "Fanwiches" competition. The delightful veggie sandwich was the brainchild of Brianne Muscente, a long-time vegetarian, who designed the sandwich after brainstorming all the delicious homemade sandwiches of her past and combining some of the best elements of each.

What the Stalwart Goatherd, and its competition, ultimately show is the power of the sandwich. As a meal, it's so flexible and easy to experiment with that you can't help but create something new, something personal. It's a meal for one, after all; no reason to try and satisfy anyone but yourself. That sort of uninhibited spirit combined with an endlessly modular assembly method means that the sandwich world is full of delicious unknowns. For every classic Club or B.L.T. there's likely a dozen Stalwart Goatherds silently enjoyed as midnight snacks or weekend lunches, blissfully anonymous and perfectly satisfied to be an undiscovered delight.

Key Ingredient | **Beets**

The Stalwart Goatherd's creator went through a laundry list of her favorite toppings to create the sandwich. Many didn't make the cut including homemade dill cucumbers, sprouts, and hummus. Beets, however, were at the top of the list. The fact they would go in the sandwich was a given.

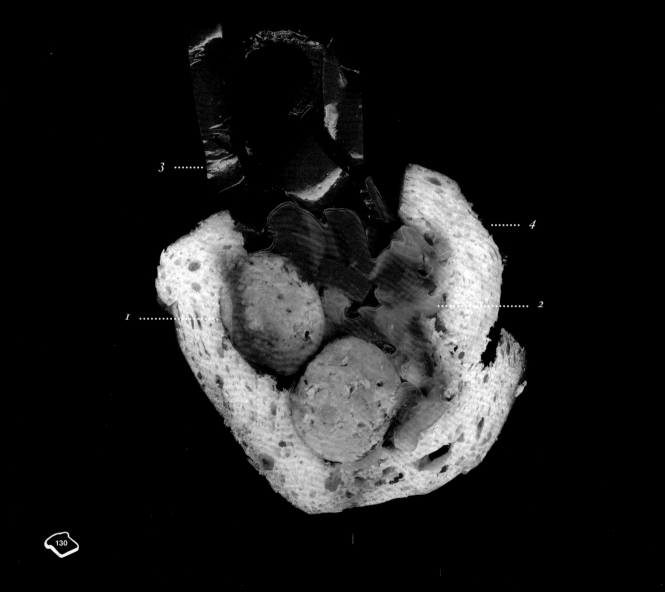

Street Fair Sausage

1 Italian Sausage, 2 Grilled Onions, 3 Grilled Peppers, 4 Hero

Siren's Smell

Every spring and summer, street fairs start popping up in cities across the United States. In New York City one of the largest and longest of these fairs is the Feast of San Gennaro in Little Italy.

Lasting more than a week, the feast fills several blocks with decorations, crowds, and vendors hawking souvenirs, clothing, and lots and lots of sausages. The smell of the onions, peppers, and sausage grilling in the open air completely fills narrow streets that are already crowded with the bodies of revelers. If you enter with even a slight twinge of hunger, by the end of a block you'll have become overwhelmed, exiting the fair with a sausage or two in hand. It's impossible to resist and foolish to even try.

Whether it's Italian, Polish, German, or Andouille, the Street Fair Sausage is the food world's Siren, longingly calling out to you, begging your embrace. And even though you know it can't be as good as it smells or taste as wonderful as you want to believe, you dive in and eat one anyway.

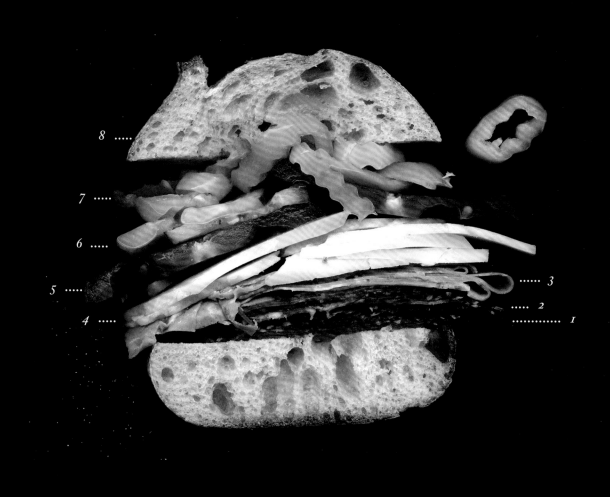

8

7

6

5

4

...... 3

..... 2

............. I

Submarine

*1 Salami, 2 Capocolla, 3 Mortadella, 4 Provolone, 5 Tomato,
6 Cucumber, 7 Banana Peppers, 8 Crusty Hero*

The Rise of the Sub

Hamburgers may be the franchise sandwich king, but following close behind, lurking just below the surface, is the mighty Submarine.

The cylindrical sandwich is known by many names. It's called a *Hoagie* in Pennsylvania, a *Hero* in New York, a *Grinder* in New England, and a *Bomber* in Buffalo. *Submarine* is one name that works no matter what part of the country or world you're in.

Originally made by Italian-American communities living in the Northeastern United States, the sandwich was served out of pizzerias in an attempt to broaden their menu. One hundred years later, the Sub has become a lucrative commodity on its own, with major multinational chains such as Subway and Quiznos selling the oblong sandwich exclusively. It's even inspired a diet, helping Jared Fogle, now a Subway spokesman, lose 245 pounds while eating the chain's Subs.

Health concerns are one of many reasons the versatile Sub has emerged a lucrative fast food contender. Every year it gets a little closer, quietly sneaking up on the mighty Hamburger, waiting to burst to the surface and claim its place as top fast food sandwich.

Name | **Submarine**

How the sandwich became known as a Submarine is a bit of a debate. The similarities in shape are obvious but the first use of the term is hard to pin down. The most convenient theory is that it earned the moniker in 1940s Groton, Connecticut, home to one of the largest submarine bases in the world.

133

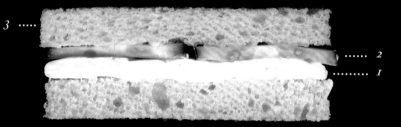

Tea Sandwich

1 Cream Cheese, 2 Cucumber, 3 Crustless White Bread

Fine Finger Food

For decades Tea Sandwiches were the preferred teatime snack of the British upper classes. The Cucumber Sandwich in particular was considered a must-have at all respectable afternoon servings, a status famously mocked through Algernon's Cucumber Sandwich craving in Oscar Wilde's *The Importance of Being Earnest.*

To make a Tea Sandwich right takes a surprising amount of preparation and skill. The bread must be just the right consistency to get the perfect cut (day old bread works best). It must be cut thin, but not too thin to hold butter or spread. The contents, especially cucumber, are often very moist meaning the sandwich must be eaten soon after making or the entire thing will soak through.

When done right a Tea Sandwich is a lovely experience to eat. They are the perfect sandwich for decadent relaxation, allowing you to enjoy bite after bite without ever feeling full.

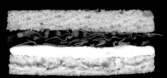

Variation | **Watercress**

Variation | **Sprinkles**

Variation | **Salmon**

Variation | **Radishes**

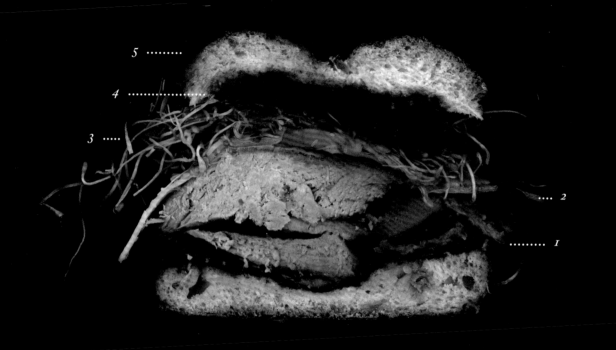

5 ·········

4 ··················

3 ·····

2 ···· ·

1 ·········

Thanksgiving

1 Roast, Dark Meat Turkey, 2 Swiss, 3 Sprouts,
4 Cranberry Sauce, 5 Buttered Roll

The Meal That Keeps on Giving

Every year on the fourth Thursday in November, families in the United States gather to celebrate Thanksgiving. Over the traditional meal of turkey, gravy, and stuffing, families remember what they're thankful for, eat their fill, and then fall asleep watching a football game. The next morning, the thanks have been given, the guests have left, but the food still remains. That's when the sandwiches start.

Thanksgiving sandwiches are as important a part of the Thanksgiving tradition as the pilgrims, and are an inspired method of getting rid of leftovers in a tasty way.

Thanksgiving sandwiches come in all shapes and sizes and almost no rules govern what can be made so long as the food is cleared out of the fridge before it goes bad. The results are often exciting, colorful, and a reason all their own to buy a bigger turkey the next year.

Ingredient | **Turkey**

Thanksgiving isn't the only big meal that prompts a week of sandwiches. Any large feast has the same effect. In Great Britain, for example, it's Christmas dinner that commonly produces an abundance of sandwich-worthy leftovers.

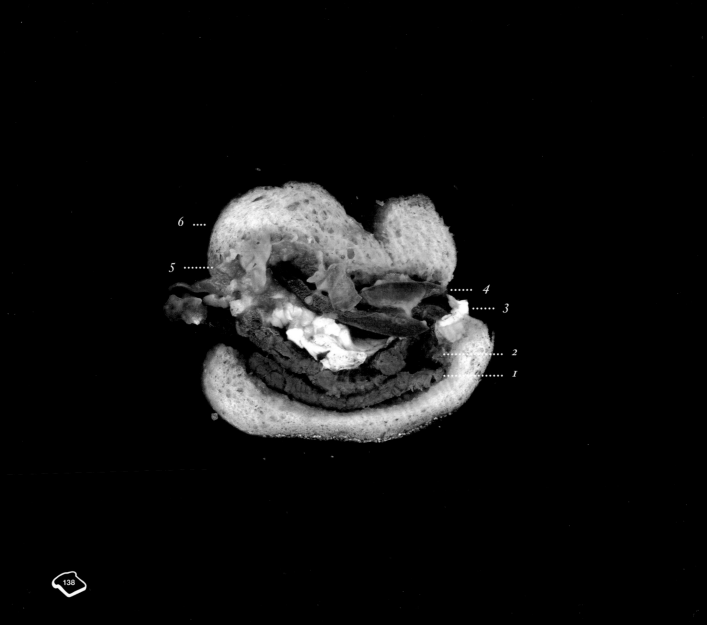

Torta

*1 Grilled Steak, 2 Refried Beans, 3 Melted White Cheese,
4 Roasted Peppers, 5 Salsa Verde, 6 Toasted Roll*

Mexico's Sandwich

It's hardly a surprise that among the diverse and rich cuisine of Mexico a sandwich would emerge.

The Torta is not just one sandwich but a whole family of sandwiches that can incorporate almost anything the maker sees fit, from grilled steak and pork, to fried fish, beef tongue, and peppers. One variation, the Torta Ahogada, is filled with carnitas (fried pork skins) before being drenched in sauce.

Tortas can be found throughout Mexico and have begun appearing in the United States as well. They're most easily found at the bare-bones taco stands and Mexican food restaurants that specialize in quick service and cheap, tasty meals.

Name | Cake?

Depending on what country, and even what region you're in, a Torta can mean different things. For most of Mexico and the United States it's a sandwich, but for many Spanish-speaking nations a *torta* is a *cake*.

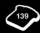

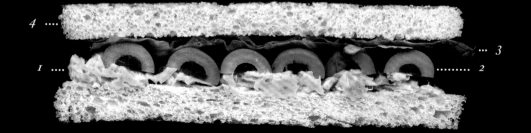

Tramezzini

1 Tuna, 2 Pimento Olives, 3 Lettuce, 4 Crustless White Bread

By Any Other Name...

For much of the world, the word for sandwich is "sandwich." Even Spanish, a language regulated by an association of Spanish speaking nations often uses the word *sándwich* to describe the whole family of food between bread.

In Italy, though, there were some people who had a problem with that. Why should they use an English word, named after an English earl, no less, to describe such an internationally relevant food? That's why Italy's version of the crustless English Tea Sandwich bears the name Tramezzini.

First offered in 1925 at Turin's Caffe Mulassano, legend says the Tramezzini was given its name by poet Gabriele D'Annunzio who sought to avoid using the word "sandwich" to describe the meal, preferring a homegrown Italian word, instead.

Today it's a popular snack across Italy, and cheap, plentiful Tramezzini are often seen stacked in windows by the dozens ready to satisfy a late-night hunger or midday munch.

Variation | **Salmon, Egg, & Lettuce**

Like the English *Tea Sandwich* and Argentinian *Sandwich de Miga*, Tramezzini come in many flavors. The Caffe Mulassano offers more than 40 varieties to its guests today.

7

... 6

......... 5

1

2

3

... 4

Tuna Salad

1 Tuna, 2 Onions, 3 Celery, 4 Mayo, 5 Tomato, 6 Lettuce, 7 Wheat Toast

Sandwich by the Can

Either by happy coincidence or through a brilliant move by the tuna industry, a 5 ounce can of tuna is the perfect amount for one Tuna Salad sandwich. Which is a good thing, because it's hard to imagine canned tuna in anything but a sandwich. Bread is the perfect vehicle for the protein-packed fish.

It's such a quick assembly, as well. Open a can, add a little mayo, some onions, and a few other ingredients and spices and you've got a meal. Few things are as simple to make but as satisfying as a Tuna Salad sandwich. It has a way of tasting so much more decadent than it ought to, and by the last bite you almost forget that it started out as a can in the back of your cupboard.

Whether it's kismet or calculated capitalism, a can of tuna is just a sandwich waiting to happen, and, in the United States, more than half of all canned tuna *is* used for sandwiches.

Ingredient | **Canned Tuna**

A bright spot in the back of the cupboard, a rediscovered can of tuna has been the savior of many a hungry bachelor or rushed parent looking for a meal when the fridge is empty.

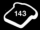

143

3

5

1

4

2

Vada Pav

..

*1 Batta Vada, 2 Mint Chutney, 3 Tamarind Chutney,
4 Peanut-Coconut Chutney, 5 Roll*

..

Indian Street Sandwich

First created in 1971 by Ashok Vaidya near the Dadar
railway station in Mumbai, the Vada Pav is India's
own homegrown, street-food sandwich.

Composed of a fried, spiced, potato patty (called a *batta vada*)
and a small roll (called a *pav* from the Portuguese word for bread,
pāo), the entirely vegetarian dish is the perfect street food for
the predominantly Hindu parts of India where the slaughter of
cows is banned and beef is noticeably absent from most cuisine.
Topped with a wide array of sweet, spicy, and dry chutneys, the
sandwich has filled the role a beefy burger would in the U.S.

A tasty meal for anyone, regardless of diet or creed, the
Vada Pav has begun appearing in cities outside India,
including some in the United States, and is a must-try for
any vegetarian bored with current veggie burger options.

Ingredient | **Dry Chutney** ..

On a Vada Pav the chutneys do much of the work. Sweet, savory, and dry
chutneys all work together to make the sandwich a phenomenal experience.

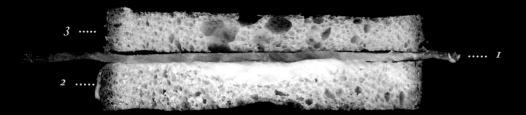

Wurstbrot

1 Sliced Ham, 2 Butter, 3 Sliced Bread

Simple Pleasure

Most of the time, the sandwiches that get all the attention
are the big, audacious combinations. The greasy Cheesesteak,
the towering Dagwood, the Double Cheeseburger. These
are the sandwiches that food bloggers drool over, restaurants
feature in their ads, and *ahem* fill the pages of this book.

With so many fantasy sandwiches bombarding us, it's easy to
forget that most of the time what people are packing to school
or work isn't a carefully constructed tower of sandwich power,
but something simple, easy to make, and satisfying. It's the
humble brown-bag sandwich, with a few slices of meat on bread,
that is the real-world, everyday, working-class hero—not the
idealized supermodels we see on the Internet and television.

The most humble of sandwiches is Germany's Wurstbrot, a
single slice of meat with butter on bread. It's the classic lunch
of the German schoolchild and a fitting entry for this book; a
reminder that not all sandwiches are exotic, unusual, colorful,
or giant, but they are all beautiful…and pretty damn tasty.

Yakisoba

*1 Yakisoba Noodles, 2 Shredded Carrots,
3 Sesame Seeds, 4 Seaweed, 5 Hot Dog Bun*

Carbo-Loading

A Yakisoba sandwich is exactly what it looks like, a healthy slathering of yakisoba noodles in a loaf of French bread or Hot Dog bun.

Popular in Japan, the Yakisoba sandwich looks like a long-distance runner's crazy last meal before a big race. Wheat noodles, covered in sauce, and stuffed into bread has to be the ultimate carbohydrate-loading meal.

It's tasty even if you're not an athlete. If you like noodles, like sandwiches, and aren't afraid of carbs, then the Yakisoba is definitely worth trying.

Unnecessary Tool | **Chopsticks**

The Yakisoba sandwich is most popular on beaches, at festivals, or any place where eating noodles the usual way would be frustrating or inconvenient. A classic sandwich solution.

149

Suggested Reads

The Encyclopedia of Sandwiches
by Susan Russo
Quirk Books
2010

A thorough guide and cookbook to more than a hundred sandwiches.

The Food Chronology
by James Trager
Henry Holt and Company, Inc.
1995

An exhaustive year-by-year reference book that follows every food footnote you can imagine from 1 million B.C.E. to the late twentieth century.

The Hamburger: A History
by Josh Ozersky
Caravan Books
2008

The best, most thorough, look at the Hamburger I've found so far. A good read for Hamburger lovers and an even better read for history buffs.

Hot Dog: A Global History
by Bruce Kraig
Reaktion Books
2009

Part of the larger *Edible Series* by Reaktion Books, an in-depth look at the mythologies, history, and evolution of the Hot Dog.

The Illustrated Cook's Book of Ingredients
Dorling Kindersley Limited
2010

A massive 500+ page visual dictionary of every ingredient you could use. Thousands of color photos. Some recipes. A great book just to skim.

Rare Bits
by Patricia Bunning Stevens
Ohio University Press
1998

A great little history/cookbook hybrid that covers many facets of food from sandwiches and sauces to breads and desserts.

Roadfood Sandwiches
by Jane and Michael Stern
Houghton Mifflin Company
2007

Quick, authentic recipes inspired
by sandwich joints around the
country, each sprinkled with a little
history and anecdote for flavor.

**Sandwich: A Global
History**
by Bee Wilson
Reaktion Books
2009

Another installment in the larger
Edible Series by Reaktion Books, a
fantastic crash course in all things
sandwiches.

Save the Deli
by David Sax
McClelland & Stewart
2009

An epic journey to the endangered
Jewish delicatessens of the world.

'Wichcraft
*by Tom Colicchio and
Sisha Ortúzar*
Clarkson Potter
2009

The companion book to the *Top
Chef* judge's popular chain.
Filled with creative (and complex)
sandwich recipes.

Roadfood Sandwiches

by Jane and Michael Stern
Houghton Mifflin Company
2007

Quick, authentic recipes inspired by sandwich joints around the country, each sprinkled with a little history and anecdote for flavor.

Sandwich: A Global History

by Bee Wilson
Reaktion Books
2009

Another installment in the larger *Edible Series* by Reaktion Books, a fantastic crash course in all things sandwiches.

Save the Deli

by David Sax
McClelland & Stewart
2009

An epic journey to the endangered Jewish delicatessens of the world.

'Wichcraft

by Tom Colicchio and
Sisha Ortúzar
Clarkson Potter
2009

The companion book to the *Top Chef* judge's popular chain. Filled with creative (and complex) sandwich recipes.